POSTCARD HISTORY SERIES

Old Saybrook

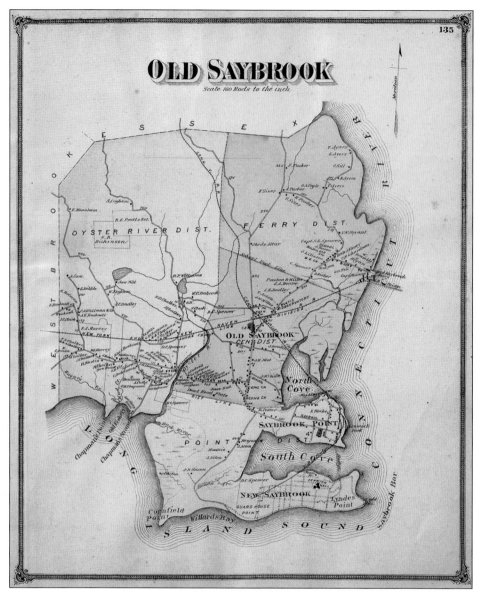

Shown here is an early map of Old Saybrook from the *County Atlas of Middlesex County*, F. W. Beers and Company, 1874. (Courtesy of Barbara J. Maynard.)

ON THE FRONT COVER: Three Saybrook men in a mahogany runabout display their catch of "blues." The Coast Guard vessel behind them was a regular harbor visitor in the 1930s. Some thought the skipper had a serious interest in a young neighborhood lady. But with the gun on the foredeck of the vessel, a more plausible explanation has to do with its being there during Prohibition to deter rumrunners. (Courtesy of Barbara J. Maynard.)

ON THE BACK COVER: Here is Saybrook's first consolidated school, which was built by John H. Tilliston in 1892. Students either walked, were brought to school by horse and carriage, were brought by trolley, or by a sleigh in the winter. Enrolment totaled 210 with some students from nearby towns. (Courtesy of Barbara J. Maynard.)

POSTCARD HISTORY SERIES

Old Saybrook

Barbara J. Maynard
and Tedd Levy

ARCADIA
PUBLISHING

Copyright © 2010 by Barbara J. Maynard and Tedd Levy
ISBN 978-0-7385-7277-2

Published by Arcadia Publishing
Charleston SC, Chicago IL, Portsmouth NH, San Francisco CA

Printed in the United States of America

Library of Congress Control Number: 2009937913

For all general information contact Arcadia Publishing at:
Telephone 843-853-2070
Fax 843-853-0044
E-mail sales@arcadiapublishing.com
For customer service and orders:
Toll-Free 1-888-313-2665

Visit us on the Internet at www.arcadiapublishing.com

*We dedicate this book to our "friends from the past" and to those
who may learn from their interesting lives and experiences.*

CONTENTS

ACKNOWLEDGMENTS

Many people helped bring this publication into existence, and we are pleased to recognize their contributions and want to publicly thank them.

Anne Sweet, Martha Soper, and Dorothy Swan at the Frank Stevenson Archives of the Old Saybrook Historical Society provided cheerful assistance and were treasured sources of local history; Bob Lorenz willingly gave countless hours of his time and skill in scanning the many images in this book; Roy Lindgren freely shared many examples of postcards from his outstanding collection; Ciel, Inc. graciously printed copies of documents and pictures at a moments notice and shared the excitement of our new finds; and many friends enthusiastically shared their knowledge, materials, or memories, and we thank them: Christina Antolino, Sarah Becker, Joanne Civitillo, Steve Cryan, George Dagon, Robert Duncan, Janis Esty, Phyllis Burgey Fowler, Eugene Heiney, Henry Josten, Teddi Kopcha, Roland Laine, Max Miller, Barbara McQueeney, Bud Senatro, Marv Smith, Roberta Smith, Elaine Staplins, Patricia Tripoli, and Ruth Weiner.

We also want to thank our spouses, George and Carol, for their patience, support, and encouragement while we pursued the pleasant task of preparing this publication.

All postcards in this publication, unless otherwise noted, are from the collection of Barbara J. Maynard. Images from the Old Saybrook Historical Society are identified as OSHS.

INTRODUCTION

This book highlights the history of Old Saybrook as shown by postcards. It is not meant to be a traditional history book that describes extraordinary individuals confronting enormous issues and making profound judgments, although there is some of this. It is a "light history" of some individual actions and everyday events that have occurred in one small area at the mouth of the Connecticut River since its settlement by English colonists in 1635.

As "light history," we think of it as shedding light on the past that sometimes does not get attention—local, ordinary, everyday, you-and-your-neighbor-type history. It is the brief visual story of a town shaped by its unique geographic location and more than 375 years of human interactions.

In preparing this book, we wanted to find and share information about the places, events, and everyday experiences of residents and visitors. To do so, we read letters, diaries, legal documents, newspaper articles, speeches, brochures, and many of the histories and other publications available on Old Saybrook. Much of this research was conducted at the Frank Stevenson Archives, and we are deeply grateful to the members of the Old Saybrook Historical Society—past and present—for their wisdom in collecting and preserving these resources and their generosity in making them available.

In addition, we talked with numerous residents and interviewed several individuals who provided information to fill gaps or contributed new understandings. And, while always searching for "new" old postcards, we met with collectors, attended postcard and ephemera shows, scoured the Internet, and when we thought we had seen it all, we would often find a fresh image. And finally, after examining hundreds of postcards and selecting those that we believe are the best available for representing life in Old Saybrook, we agonizingly condensed large amounts of data into painfully short paragraphs.

Since Lion Gardiner first built Saybrook Fort at the mouth of the Connecticut River in 1635, Saybrook has had a distinguished history. This publication features some of the historic places, important events, and interesting people who have lived, worked, and played here over the years. We have attempted to include observations about the town's early history but given that we are using postcards, and none were available for early history, most of this book focuses on the first half of the 20th century.

An observant individual can find considerable evidence of earlier days on the plaques on old buildings, in the stone walls running through wooded areas, the names of streets, the arrowhead pillars on the Boston Post Road, the large elm trees, the war memorial on the town green, the "Old Ben Franklin Mile Stone" with 41 miles to Hartford, the plaque on the walkway over the Baldwin Bridge, the Yale boulder, the old millstone, the reproduced water pump, the cemeteries, Saybrook Fort park, the railroad roundhouse, the Lion Gardiner statue, and the George Fenwick marker. All are easily seen reminders of our rich and varied, if sometimes unfamiliar, history.

Some history calls for more probing. It is the more knowledgeable local history authority who knows why and where a reservoir was constructed that is no longer used, or how the causeway became a roadway, or what those poles are that are seen at low tide between Saybrook Point and Fenwick, or the location of the milestone showing "Hartford 40," or what business was carried on in the building with the 200-foot chimney, or the location of Connecticut's first underwater archaeological preserve.

It was, and is, the people of Saybrook who made the most significant difference in the development of the community. A community includes many who are remembered by family stories or fragile letters and fading photographs of summer at the beach. And this community has also included those who have achieved wide recognition in government, science, education, literature, and the arts.

Around the turn of the last century, the town was the summer residence of Morgan Bulkeley, mayor of Hartford, governor, U.S. senator, and first commissioner of the National Baseball League. Less well-known, it was the home of the family of Samuel F. B. Morse, a stopping-off place for Charles Dickens as he toured the United States, and the place where Mark Twain may have begun writing *The Adventures of Tom Sawyer*. It is also the town where George Beach rented his "castle" for $1 a year to house World War I soldiers.

Anna Louise James became the first female African American pharmacist in the state and for 60 years dispensed medicines and good advice. Saybrook-born Maria Louise Sanford became the first woman professor, and one of the few women to be honored in the U.S. Capitol at the National Statuary Hall. It has also been the residence of noted author Ann Petry and famed movie actress Katharine Hepburn.

From the early 1900s to about the time of the "Great War," postcards provided quick and easy communication for sharing views of other places, a tourist attraction or even a foreign country. So many millions were sent during this time that it is commonly referred to by collectors as the "Golden Age of Postcards."

They gained popularity with improved and inexpensive postal services, the spread of Kodak's handheld box camera, and the growing popularity of automobiles. Postcards brought the world to rural areas. The camera allowed photographers to easily capture new images. And the automobile provided the common person with mobility to visit beyond a limited geographic area. Tourism promoted hotels, resorts, and the automobile trip, and people wanted to document and preserve their memories of these experiences.

Millions of these images were saved and displayed in family albums and, thankfully, provide a record of main streets, schools, factories, courthouses, railroads, monuments, landscapes, and tourist attractions. Today they provide an honest and unsophisticated look into the past.

There were several publishers and local businesses that dealt in postcards. With the invention of the postcard rack in 1908, customers made their own selections. Locally, postcards were printed for James Pharmacy and J. A. Ayer. Others were published or sold by Libby's Store, Watson's Drug Store, H. T. Chapman, and G. L. Burrows in Essex, or the Hunter Photography Company in Madison. Among the most popular were those issued by W. J. Neidlinger in Westbrook and those produced by Hauser Bob, although little is known about him, and he is occasionally referred to as Bob Hauser.

We have gathered over 200 images of Old Saybrook from the first half of the 20th century and created a community album. Here we have presented the early settlement around Saybrook Point, the growth around town, the houses and inns, schools and stores, automobiles and carriages, railroads and trolleys, ferries and bridges, and life at the beach and along the shore.

We should also note that until 1947, the name Saybrook also referred to the community we know today as Deep River. Both Saybrook and Old Saybrook were used to describe the area we today refer to as Old Saybrook. We have used Saybrook and Old Saybrook interchangeably and in ways we thought most appropriate. Furthermore, throughout the years, Saybrook has been spelled in various ways although we have kept with today's common spelling.

We hope our "pictures and a paragraph" stimulate your interest in finding out more and in sharing your own memories with your family and friends. We also recognize that, however conscientious we were, there may be some errors, omissions, or misinterpretations, and we invite you to send your corrections and suggestions to the Old Saybrook Historical Society.

—Barbara J. Maynard and Tedd Levy
December 17, 2009

One

SAYBROOK POINT

Uncas
Chief of the Mohegans

The "place at the river's mouth," or Pashebeshauke, was the Algonquin-Nehantic name for their village, now the location of Old Saybrook. The English arrived in 1635, built a fort, and designed a town that today includes Chester, Deep River, Essex, Lyme, Old Lyme, Westbrook, and Old Saybrook. Soon after, Uncas, the sachem of the Mohegans, joined with the English to nearly annihilate the more warlike Pequots. With English support, Uncas and the Mohegans became a powerful tribe.

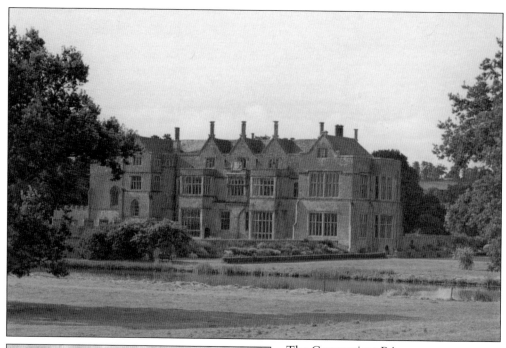

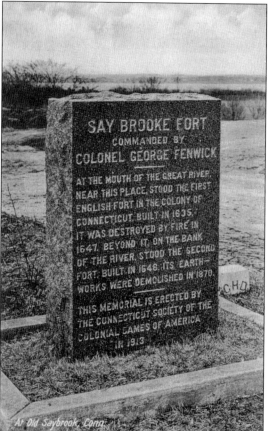

At Old Saybrook, Conn.

The Connecticut River area was explored in 1614 by the Dutch under the leadership of Adriaen Block. Later attempts to establish a colony at Saybrook Point were unsuccessful. In 1631, the English Earl of Warwick gave several friends including Viscount Saye and Sele, Lord Brook, and later Col. George Fenwick, a deed called the Warwick Patent. The patentees met at Broughton Castle, home of Lord Saye and Sele, to plan a new colony.

The patentees made John Winthrop Jr. the governor of the territory and hired Lt. Lion Gardiner to build a fort and lay out a town. He arrived at Saybrook Point on November 24, 1635, and successfully set about his task. Governor Winthrop arrived later and named the settlement Saye-Brook, in honor of the two patentees. Recognition of the fort was made by the erection of this monument in 1913. The site was later developed into a public park and dedicated on July 4, 1985, the colony's 350th anniversary.

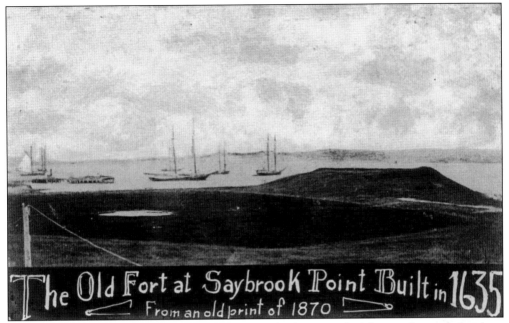

The Old Fort at Saybrook Point Built in 1635
From an old print of 1870

After its destruction by fire in 1647, a new fort was built near a glacial mound next to the river. Through the years, the area served as a natural harbor with sailing ships depositing passengers and supplies near the fort. However, the site was leveled and used to fill the low areas so that the Connecticut Valley Railroad could lay tracks and built a roundhouse in 1870–1871. The site was eventually deeded to the state. In 1981, it was returned to Old Saybrook for use as a park.

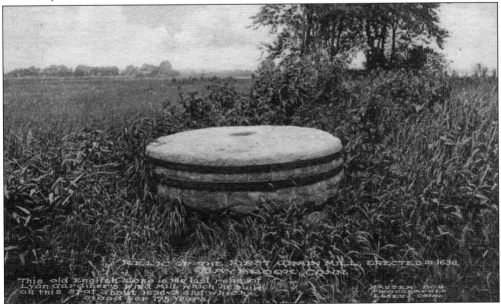

These old English stones are the last relics of Lyon Gardiner's windmill, which he built near this spot about 1635. These grinding stones were brought from England as ballast in ships. During the first years of the mill's use, the fort residents needed protection from unfriendly natives. Ground grains and corn, game and seafood were staples of the settler's diets. These stones are close to the original location and can be seen from the road to Saybrook Point.

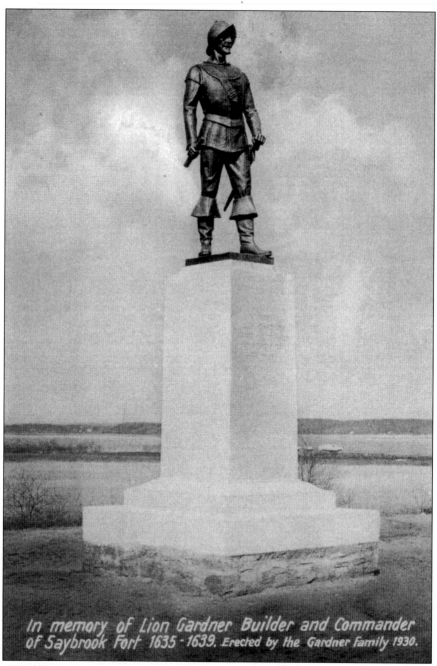

In memory of Lion Gardner Builder and Commander of Saybrook Fort 1635-1639. Erected by the Gardner Family 1930.

Lt. Lion Gardiner was an engineer and soldier hired by John Winthrop Jr., for four years, to design a town and build a fort at Pasbeshauke, the Indian name for today's Old Saybrook. He arrived in 1635 with 18 men, and several women and children. The following April, his wife, Mary, gave birth to the first European child born in the colony. When his service ended, he bought an island in Long Island Sound and moved there. Today it is known as Gardiner's Island and is owned by his descendants. In 1930, Gardner family members arranged to have a statue placed near the fort site. On a granite base, the bronze figure is 8-feet high and was the last work of sculptor William Ardway Partridge.

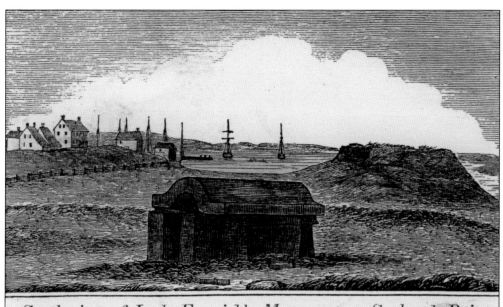

South view of Lady Fenwick's Monument on Saybrook Point.

In 1637, Col. George Fenwick, the only patentee to come to the colony, took over as governor. His wife, two sisters, and an infant son accompanied him, and they lived within the fort. Lady Fenwick raised a garden with fruit trees and hunted game for the fort's food. She died after giving birth in 1648 to a daughter and was buried in the fort. In 1871, Lady Fenwick was disinterred and placed in the Cypress Cemetery. Her remains were examined by two town doctors, a few snippets of her still auburn hair taken, and she was placed in a casket, and reburied. Also buried at Cypress are some slaves and Native Americans, including Attawanhood, son of Uncas and sachem of the Niantics. A "dreadful storm" in 1815 washed some graves away. The cemetery was restored in the mid-1800s, and an iron fence was given by Jeanette Hart, one of the seven Hart sisters.

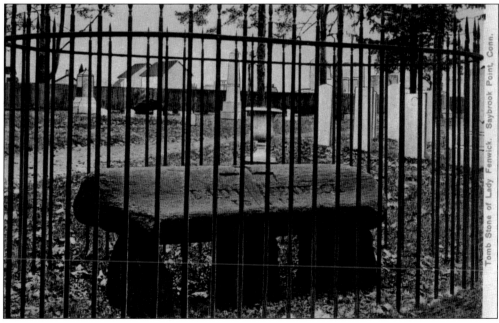

13

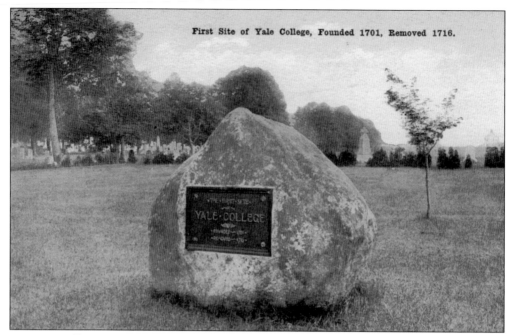

In 1701, a collegiate school was authorized by the Connecticut General Assembly for "the liberall education of youth that by God's blessing may be fit for publick service," and Nathaniel Lynde gave a one-story building and 10 acres for the school, so long as it remained in Saybrook. The first rector was the Rev. Abraham Pierson, and his first student was Jacob Heminway. The first commencement was held in 1702 in Rev. Thomas Buckingham's house.

This painting by a local artist is of a bas-relief, which is on the front of the Beinecke Rare Book and Manuscript Library at Yale University. The sheriff's men were trying to hold off disgruntled local residents who unsuccessfully objected to the removal of the school and its books. Some 1,000 books were transferred and are located today at Saybrook College at Yale University. However, an estimated 250 others were "lost" and never arrived at Yale.

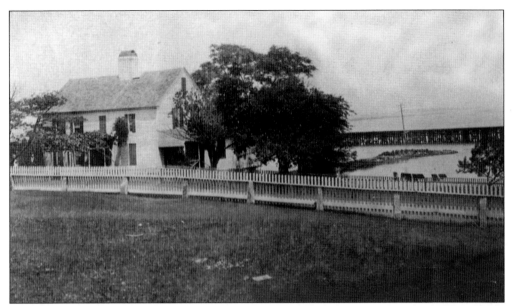

The Tully house on North Cove was the site of Saybrook's most noted American Revolution battle. On August 8, 1779, William, 20 years old, faced eight Tories seeking entry into his house for supplies. They forced the door and rushed in. William fired his musket with the ball piercing the body of the first man and lodging in the second, killing both. He then charged them with his bayonet and jumped through the window to alert the fort garrison. Since then it has come to be known as "Tully's War." The train trestle in the background led to Saybrook Point from 1871–1916.

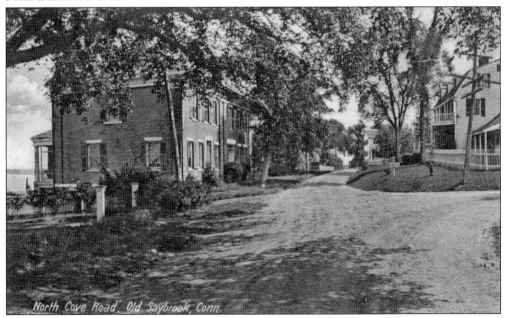

This brick home was built in 1830 by Capt. George Dickinson (1770–1857). For many years, he was a shipmaster. The captain designed and located his home near the water for his shipping business and easy access to the wharfs. Hogsheads of rum and molasses were rolled along a lane to his cellar, which then led to the water. The west end of the house was a ship chandler.

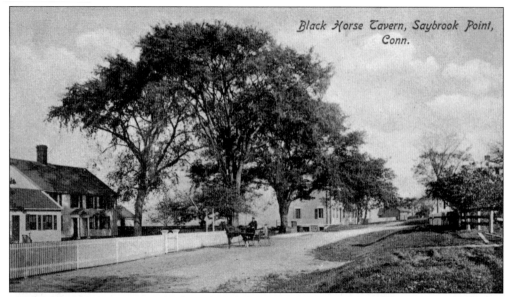

The Black Horse Tavern was built, and probably used as an inn, by Capt. John Burrows in the early 1700s. The building was also used as a customs house when Saybrook was a port of entry. Another owner, Henry Potter, built a dock for trading vessels on the North Cove and a store on the northeast corner of the site, which he ran with his son from 1866 to 1890 and then sold to his clerks, Robert Burns and Frank Young.

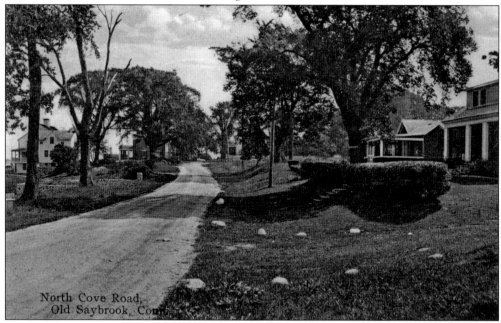

This view of North Cove Road, originally called Water Street, was the town's main harbor until the railroad restricted entry to the North Cove in 1871. Numerous wharfs lined the shore, and dozens of sailing ships lay at the mouth of the Connecticut River known as the "Anchoring Ground." Ships loaded with lumber, hay, livestock, and iron items traveled to the southern states, West Indies, Europe, and Africa and returned with sugar, molasses, rum, and occasionally African slaves.

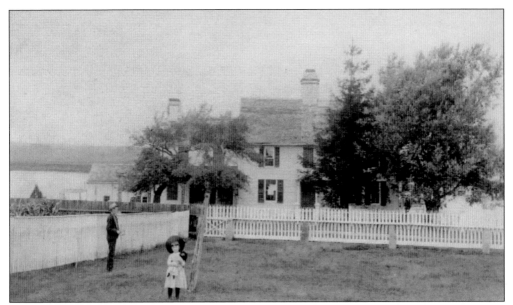

This 1887 view shows Irene Martindale, the granddaughter of Edward and Amelia Ingraham, at their house on North Cove Road. The house was built in the early 1800s by Edward's uncle, Capt. George Dickinson. Edward's grandfather was Capt. Richard Dickinson, who was appointed surveyor of the port of Saybrook by George Washington in 1795. Later it became the home of Capt. Frank Harding, a captain of Merchant Marine vessels in World War I and in 1960, it became the home of Robert Childress, who illustrated the famed Dick and Jane series of children's schoolbooks.

RESIDENCE OF H. N. BEEBE, SAYBROOK, CONN.

This is an early home in the Saybrook Point area. Many early homes had stone pillars or metal posts that were used to support fence sections. The fences were common and necessary to protect gardens and confine farm animals.

This house was built in the early 1840s by a Captain Williams and is shown in this 1890 photograph taken from a "tower" that was attached to an adjacent home. In the distance is Saybrook Point, where a Connecticut Valley Railroad train is at the roundhouse. To the far right is South Cove, and across the cove is Fenwick Hall. This historic home on Cromwell Place, earlier called Fenwick Street, remains in its original location. (Courtesy of OSHS.)

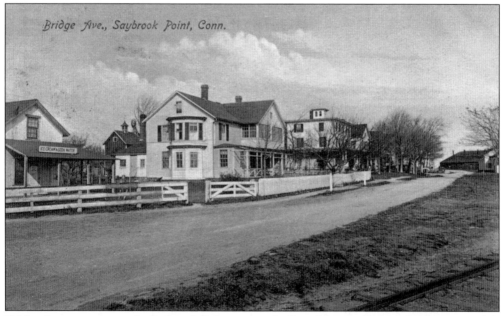

Bridge Avenue connects the Saybrook Point area to the Fenwick area. This card shows a captain's house and the warehouse where ships unloaded and passengers could board the Connecticut Valley Railroad train (tracks in lower right). From the 1870s, for nearly 50 years, the train crossed South Cove to make its last stop at the station in Fenwick.

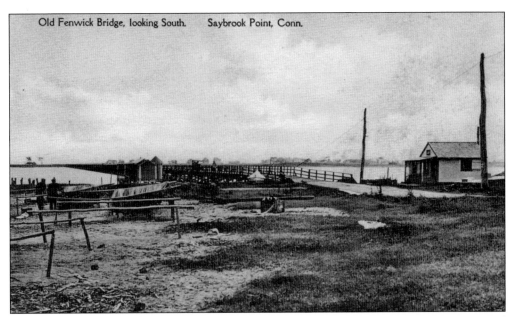

Old Fenwick Bridge, looking South. Saybrook Point, Conn.

Shad nets are shown drying on the shore of South Cove. Fishing was an important commercial activity. An early story told of a Saybrook fisherman who put pebbles in the fish so they weighed more before shipping them to Hartford. The Hartford dealers eventually found out and confronted the fisherman. "Oh," he said in shock. "I never before believed the tale but I have heard that when a storm is coming up fish swallow pebbles for ballast." His feigned astonishment so convinced the dealers that they returned with the pebbles to Hartford.

Saybrook Point, Conn.— 1914.

This early view is looking north from the Saybrook Point area. In the far distance is the Old Lyme shoreline. The long pier to the deep water was used by Connecticut River steamboats, many of which docked there to visit the Pease House, a famous shoreline restaurant.

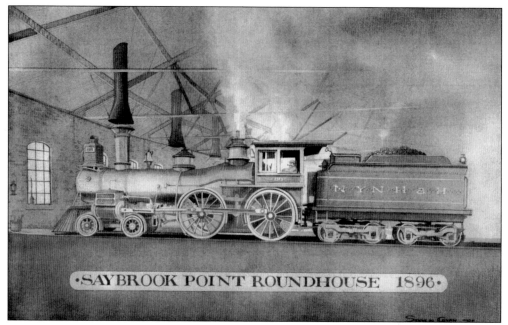

·SAYBROOK POINT ROUNDHOUSE 1896·

From 1871 until 1916, steam engines turned around inside the roundhouse at Saybrook Point. The railroad provided fast, reliable travel to the shore and led to the rapid increase of summer cottages and resorts. Fill from the old fort site was used across South Cove so a railroad spur could reach Fenwick. The service was discontinued, and the causeway constructed for automobiles. In 1925, the railroad also deeded the old fort site to the state. (Courtesy of Steve Cryan.)

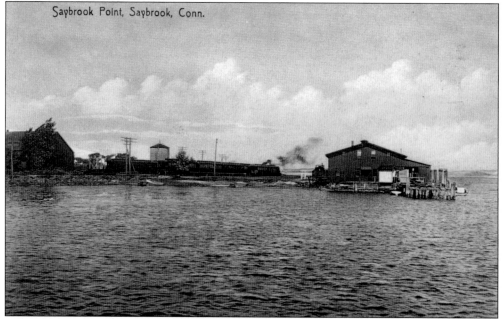

Saybrook Point, Saybrook, Conn.

Passengers transferred from steamboat to train at the large dock and continue on to Saybrook Junction, where they could travel to many destinations. When the railroad ceased operating at this site in 1916 the land along the waterfront was sold and the remaining land was deeded to the state. This is the approximate location of today's pavilion.

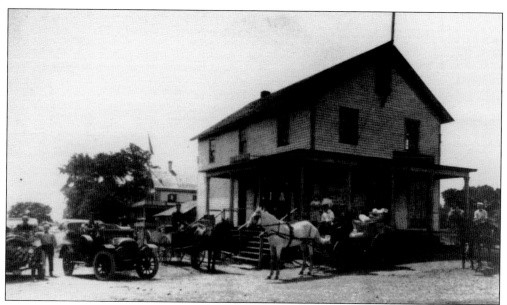

This building housed Fred Faulk's store and the Saybrook Point Post Office, at the corner of Bridge and College Streets. This general store was started by H. C. Chapman, in the late 1800s, and served Fenwick, Saybrook Point, and the North Cove areas. Ship captains also obtained their supplies here before leaving the river. Springwater from Seldens Island, across from Deep River, was taken in casks for long voyages.

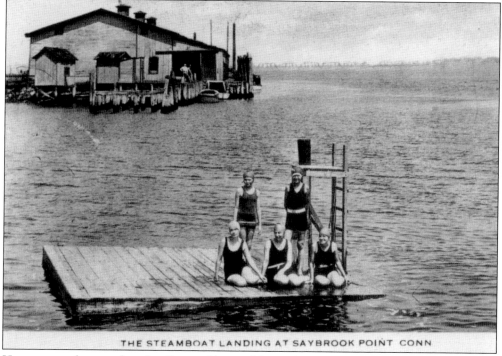

THE STEAMBOAT LANDING AT SAYBROOK POINT CONN

Here next to the steamboat landing, residents of the Saybrook Point enjoyed swimming during the 1920s. Swimming, boating, and fishing provided three seasons of recreation. In the winter, ice often covered the river, and wagons could cross safely.

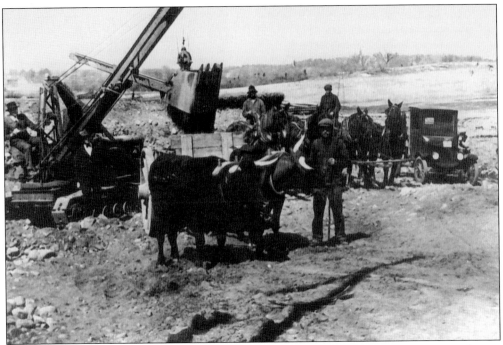

The Saybrook Point area spread out with the construction of sea walls, boat docks, and new homes that were built on formerly large tracts of farmland. This image, about 1920, of oxen, horses, a steam shovel, and a truck, shows the transition from horse and ox power to steam and gas.

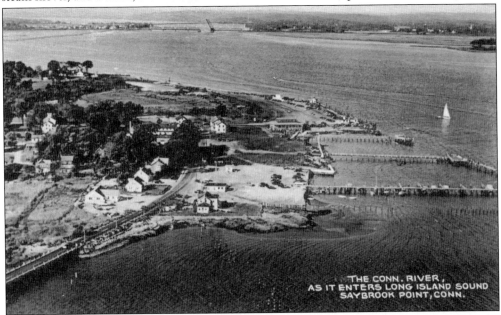

THE CONN. RIVER, AS IT ENTERS LONG ISLAND SOUND SAYBROOK POINT, CONN.

Extensive development had not yet started at Saybrook Point when this view was made in the mid-1930s. The former Fenwick railroad station, now with a porch and made into a restaurant was called the Pantry. Clarks Fish Market is the white building at the river's edge. The Pease House is partially hidden behind trees. Hull Harbor Marina is in the forefront as is the causeway and Bridge Street. In the distance, the railroad bridge is shown open.

The Pease House was built by William Pease in 1871 and operated as a hotel, livery, and feed business. After remaining in the Pease family for many years it was sold to Frank Brennan in 1920, and he turned it into a well-known shoreline landmark restaurant.

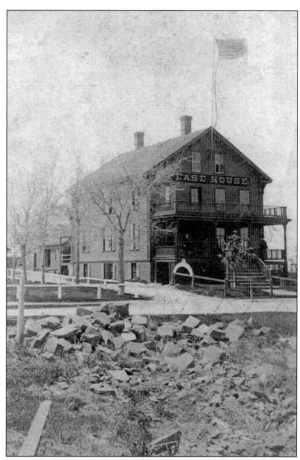

The famous restaurant expanded as did its fame. Patrons arrived by yacht as well as automobile. Among the more famous diners was James Roosevelt, whose father remained offshore, aboard the USS *Sequoia*. Special boat trips from New York and Hartford allowed time for patrons to enjoy the famous menu—"double lobster – soup to nuts cost $3.50!"

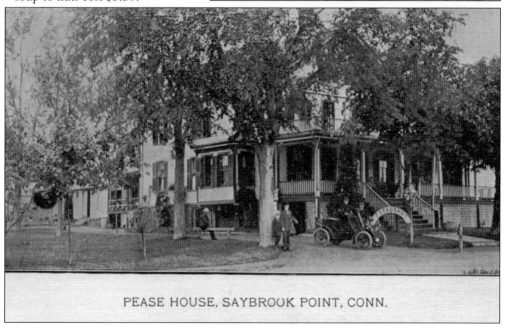

PEASE HOUSE, SAYBROOK POINT, CONN.

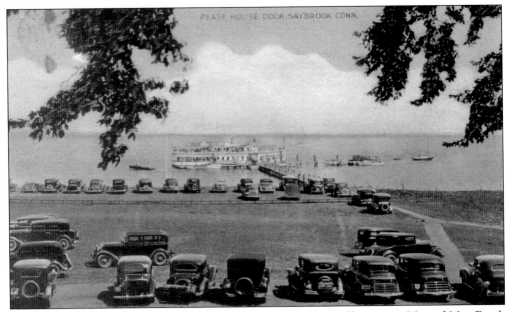

Once the boats docked, eager diners were enthusiastically welcomed by owners Mr. and Mrs. Frank Brennan and their beautiful English setter. Diners sat at perfectly set tables and lit their Chesterfields, using matchbooks designed to look like peas in a pod. Many state and local groups held their functions here. During World War II, special events were held for navy men from New London. It was the favored location for family events and graduations. (Courtesy of Bob Duncan.)

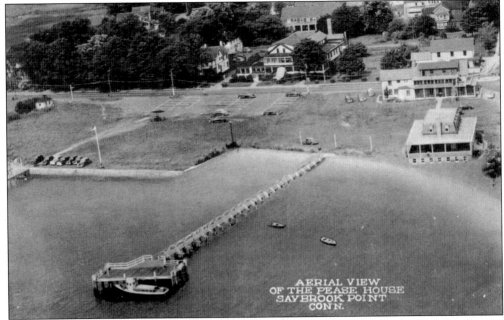

The Pease House dock, shown here with the launch, was a popular stopping place for pleasure craft. This deepwater dock was used by steamboats arriving from New York, Hartford, and Middletown, until they stopped running in 1931. The Pease House was Connecticut's favorite shoreline restaurant, until it was sold in 1956 and torn down the next year to construct the Terra Mar, a seasonal resort and marina. This is now the site of the Saybrook Point Inn and Spa.

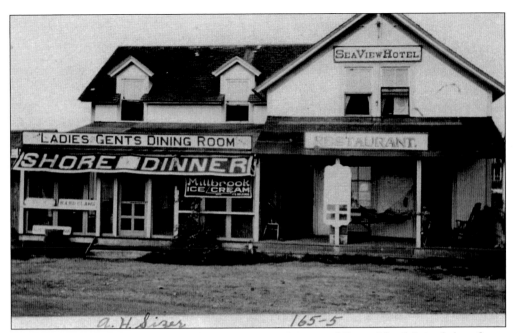

Many inland residents traveled to the Connecticut River and Long Island Sound shorefront. There was no shortage of seafood restaurants waiting to serve them. Sizer's Restaurant, which included a fish market, at the Sea View Hotel was located on the shore of South Cove on Bridge Street. (Courtesy of Roy Lindgren.)

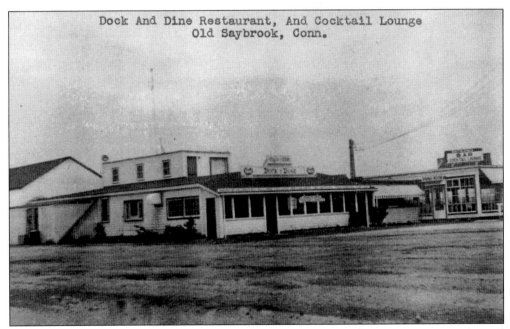

This early view shows the Dock and Dine Restaurant and bar and cocktail lounge. It is located on the waterfront at Saybrook Point, on land sold by the Connecticut Valley Railroad when it ceased operations. Nearby is the site of the original fort, the railroad roundhouse, and a small park commemorating the arrival of Lion Gardiner. (Courtesy of Roy Lindgren.)

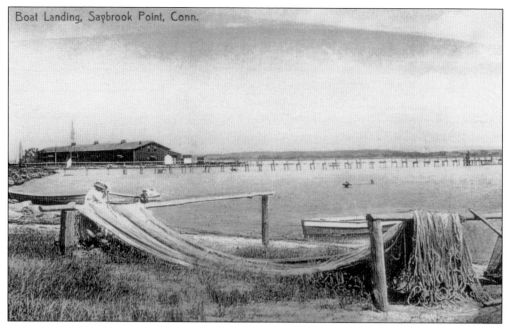

Boat Landing, Saybrook Point, Conn.

Salted shad was a principal food, and locals reportedly did not mind the bones. An old-timer explained that the shad went into one corner of their mouths, and the bones came out the other, like a person playing a harmonica. Some people, he explained, were unable to get their flannels off until July because of bones sticking out of their hide. When cutting salt meadow hay, men said they felt so much like a shad, they hid from fish hawks.

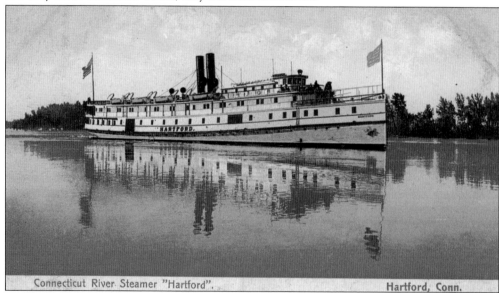

Connecticut River Steamer "Hartford". Hartford, Conn.

The first regular passenger steamer traveling the Connecticut River was the Oliver Ellsworth in 1821. By the 1860s, the journey between Hartford and Saybrook took a full day. The Hartford began passenger service in 1892 and was the first twin-screw propeller vessel to replace the old side-wheelers. It was sold to the government during the Spanish–American War and replaced with a "new" Hartford in 1899. Unable to compete with the railroad or automobiles, it was forced to discontinue service in 1931.

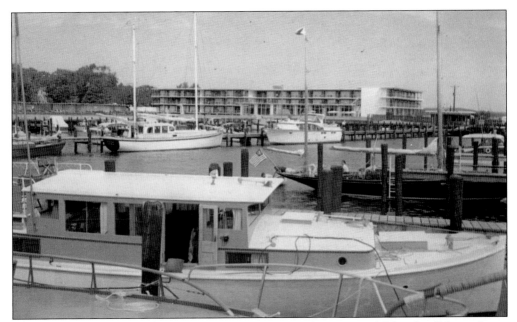

The Terra Mar opened in 1959 as a restaurant, hotel, and marina, and "the place" for yachters, politicians, actresses, and actors from Ivoryton Theater. It offered swimming pools, a cocktail lounge, cabana club, and shops. Stories spread through town that many notable people "played" there, and organized crime figures became frequent guests. Police raids, suspended liquor permits, and unpaid taxes led to the demolishing of the Terra Mar in the 1980s and the building of Saybrook Point Inn. (Courtesy of Robert Duncan.)

This view of Saybrook Point shows the Dock and Dine Restaurant, the miniature golf course, and Gees Pond, partially enclosed from earlier railroad construction. The pond area was a small harbor used by schooners. The old railroad right-of-way crosses North Cove.

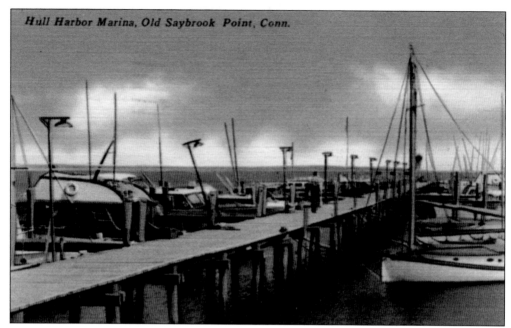

Hull Harbor Marina, Old Saybrook Point, Conn.

Easy access to Long Island Sound's pleasure boating and good fishing attracts weekend vacationers to local marinas. One marina that has been operated by the same family for many years is Hull Harbor Marina at Saybrook Point. (Courtesy of Eugene Heiney.)

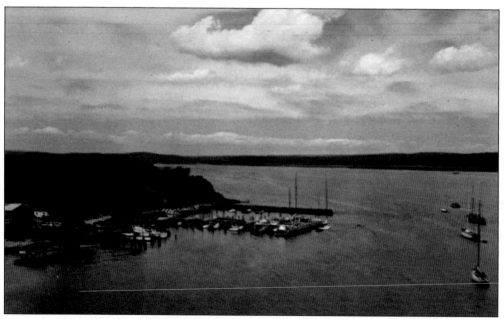

From the Baldwin Bridge (built in 1948), where this postcard image was taken, one can see far up the Connecticut River. Beyond today's marinas and boatyards, at Ayer's Point in 1775, young David Bushnell invented the submarine, which was first used against the British in the American Revolution. Called the "American Turtle," it was unsuccessful in its attempts to sink British ships. Essex harbor lies around the bend, an important early shipbuilding site.

Two

AROUND TOWN

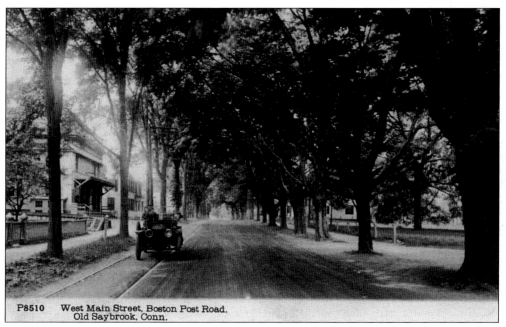

P8510　West Main Street, Boston Post Road.
　　　Old Saybrook, Conn.

An automobile pauses for the photographer on West Main Street, now called Old Boston Post Road. The building on the left was the original Episcopal church, moved here in 1870 to make space for the present Grace Episcopal Church on Main Street. The white house, next to the church building, is now the Feed Bag store. (Courtesy of Roy Lindgren.)

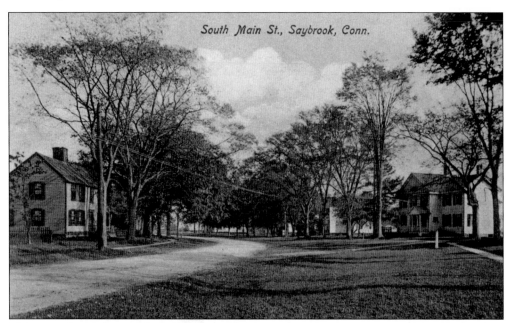

This view shows the gravel road, known then as South Main Street, one would use to travel to or from Saybrook Point in the early 1900s. The Reverend Thomas Buckingham house, on the left, was the place of the first Yale commencement. This card was mailed July 14, 1910, to Harry Acton, Nome, Alaska, from his mother who lived in Saybrook.

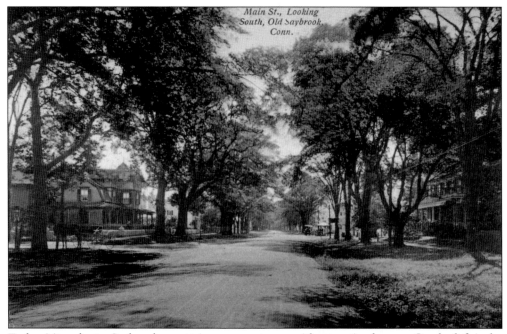

Early visitors knew Saybrook as a quiet country town with attractive homes. On the left is the Nelson Bowes house, now the site of the fire department. Next to it is the Kirtland house, now home to Saybrook's Youth and Family Services. In the distance might be seen horses and carriages at the town pump.

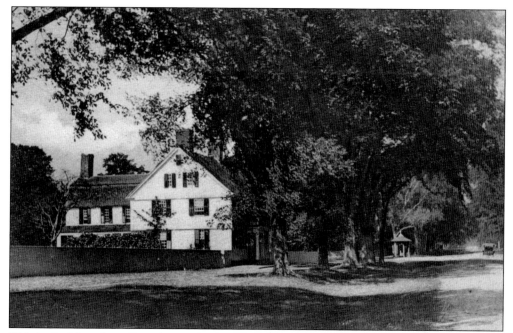

This is the Humphrey Pratt house, built in 1785. It was a stop for the stage running between Boston and New Haven and was known as Pratt's Tavern. The first post office in town was in a small room in the rear of the house. Many homes on Main Street had large lots, a barn or carriage house, a vegetable or herb garden, and fruit trees.

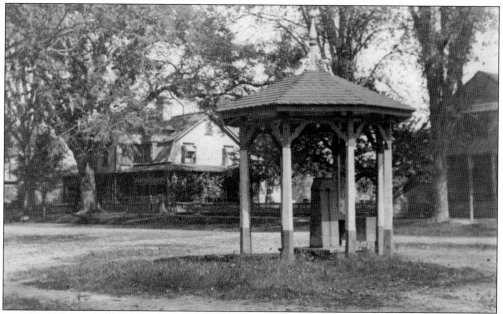

The public well was dug with private contributions of $128 "for the accommodation of man and beast." Horses drank from the trough, and people drew well water to the surface with a rotary hand crank that had small cups attached to an endless chain. Many pictures of the area showed groups gathered at the town pump. In the background is the Bushnell store, later to become the first location of Stokes' Brothers store.

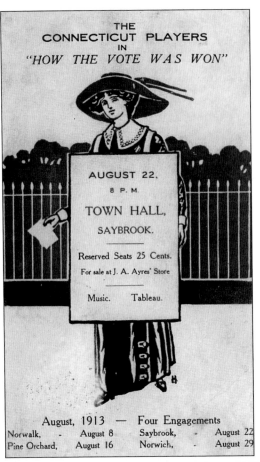

THE
CONNECTICUT PLAYERS
IN
"HOW THE VOTE WAS WON"

AUGUST 22,

8 P.M.

TOWN HALL,

SAYBROOK.

Reserved Seats 25 Cents.

For sale at J. A. Ayres' Store

Music. Tableau.

August, 1913 — Four Engagements

Norwalk,	August 8	Saybrook,	August 22
Pine Orchard,	August 16	Norwich,	August 29

In 1905, a small group formed the Old Saybrook Musical and Dramatic Club to raise money to purchase land and provide a building suitable for town and social purposes. Members raised money by giving plays, concerts, and suppers. In 1909, the town accepted the club's donation of land and funds. A building with an auditorium with large arched windows was constructed. This early announcement promotes a performance of *How the Vote Was Won*, a one-act play on women's suffrage. (Courtesy of Roy Lindgren.)

Initiated by the Old Saybrook Musical and Dramatic Club, this building was dedicated in 1911 as a town hall and a place for dramatic performances and other activities. It was a multipurpose building with an auditorium and stage, banquet hall, kitchen, dressing room, jail, and two solid masonry vaults for town records. It was the site for town meetings, elections, court, the police station and jail, basketball games, an emergency Red Cross shelter, and classrooms when schools were expanding. In 1962, the entire building was used for town government purposes.

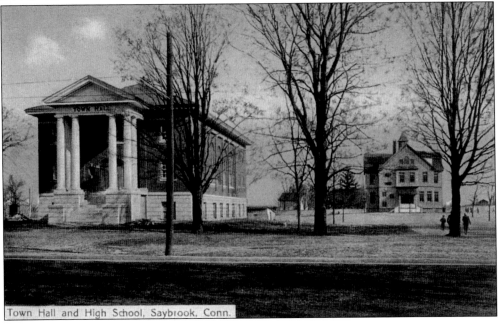

Town Hall and High School, Saybrook, Conn.

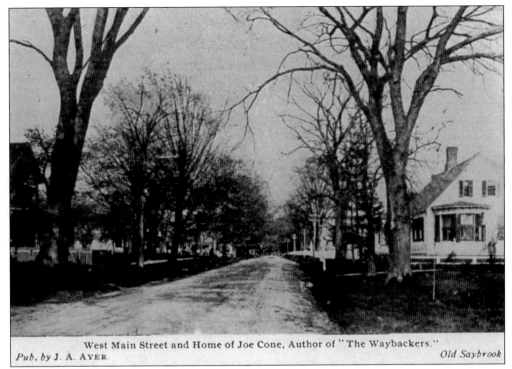

West Main Street and Home of Joe Cone, Author of "The Waybackers."
Pub. by J. A. AYER. *Old Saybrook*

Joe Cone grew up in East Haddam, then lived and worked during the last of his too-short life in Saybrook. He was an accomplished writer, musician, machinist, artist, and above all, a humorist. He organized the Old Saybrook Musical and Dramatic Club that raised enough money to build the town hall for plays, concerts, and dances. (Courtesy of Roy Lindgren.)

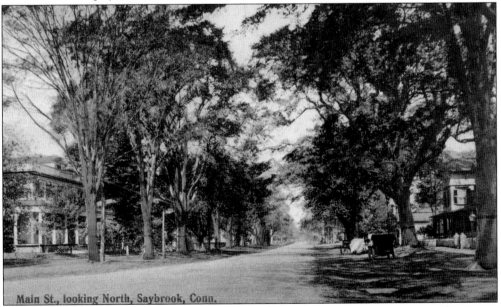

Main St., looking North, Saybrook, Conn.

On the corner of the Old Boston Post Road and Main Street is Ye Olde Saybrook Inn, shown here on the left. An automobile and horse and carriage are parked across the street in front of the Bowes house.

33

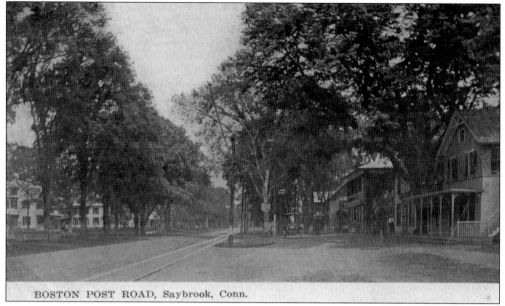

BOSTON POST ROAD, Saybrook, Conn.

The store on the right sold Glenwood stoves and accessories. The new brick building was the second location of Stokes Brothers store. The home past the store was owned by Samuel Morse's family. The inventor lived in Saybrook for a period of time.

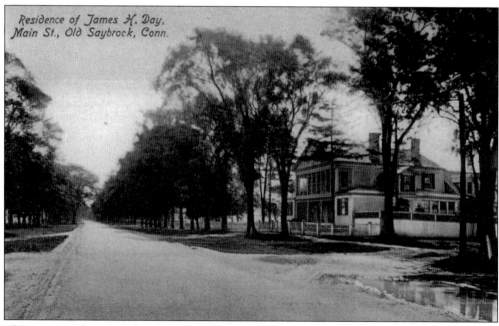

Residence of James H. Day, Main St., Old Saybrook, Conn.

This gracious home at the corner of Elm and Main Streets was occupied by at least three generations of the Day family. The house was torn down to construct the town's first super market, a First National Store. State senator James H. Day was instrumental in getting a toll for the first Connecticut River bridge, which was removed when the bridge was paid for. Other Day family members also held political offices. (Courtesy of Roy Lindgren.)

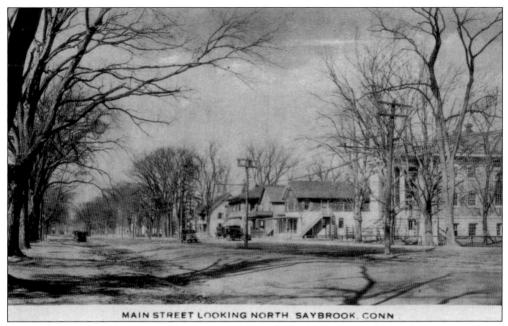

MAIN STREET LOOKING NORTH, SAYBROOK, CONN

Along the wide Main Street, the new town hall and several stores can be seen. It must not have been a busy day, as there are only four cars on the street.

Old Saybrook, Connecticut

This house was built in 1767 for Gen. William Hart, an officer in the Continental Army. He was a prosperous merchant who traded in the West Indies and a land speculator in the Western Reserve in Ohio. During the Civil War, Hetty Hart Wood ran a boarding and day school in the house. It was purchased in 1974 by the historical society, and it is listed in the National Register of Historic Places.

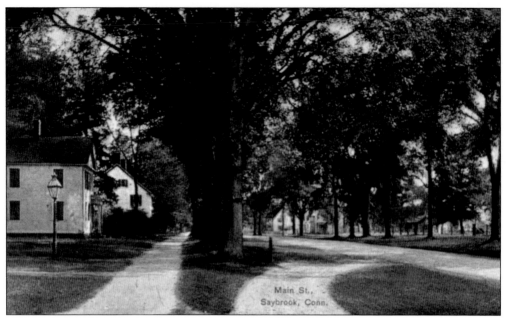

This view of Main Street shows the Gen. William Hart house second on the left. His brother, Elisha, married Janet McCurdy of Lyme and moved into his parent's house further north on Main Street. Elisha and Janet had seven popular and beautiful daughters. Of those daughters, Ann married Commodore Isaac Hull, Amelia married a nephew of the Commodore's, Elizabeth married the Hon. Heman Allen, Minister to Chile, and Jeannette was pursued by Simon Bolivar, known as the Liberator of South America.

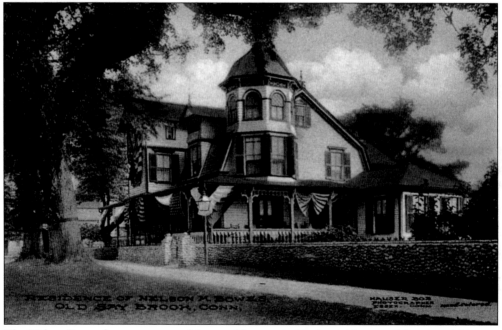

The Nelson Bowes house was an architectural beauty and is shown decorated for a special event, possibly the opening of the new drawbridge, August 1911. Note the beach stone wall with wrought iron trim. (Courtesy of Roy Lindgren.)

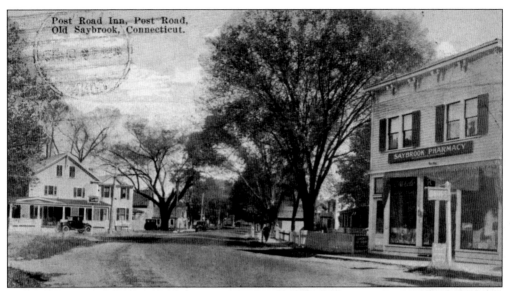

Located at the north end of Main Street was the Saybrook Pharmacy. Later half of the building became the Western Union office. Across the way was the Coulter House, a restaurant and hotel that rented rooms for $12 a week and served whiskey for 10¢ a glass. In 1932, a new owner named it the Lady Fenwick and specialized in New England turkey dinners. Today it is known as the Monkey Farm. The road was known as the "road to the ferry."

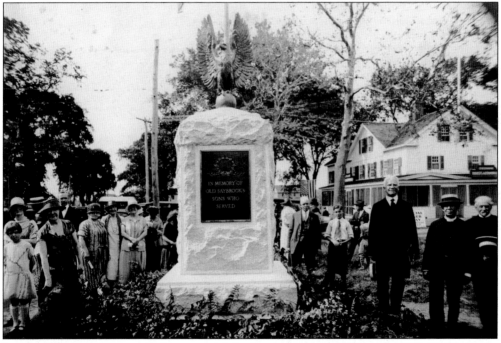

In July 1926, the town unveiled a memorial for those who participated in the "World War." The monument is a shaft of Barre, Vermont, granite on a 5-foot base with an 8-foot column, topped by a bronze eagle. It was originally placed at Main Street and Middlesex Road (now Boston Post Road) and is now in front of the town hall. The tablet reads, "In Memory of Old Saybrook's Sons Who Served." The names of those who served are on the back of the monument. (Courtesy of OSHS.)

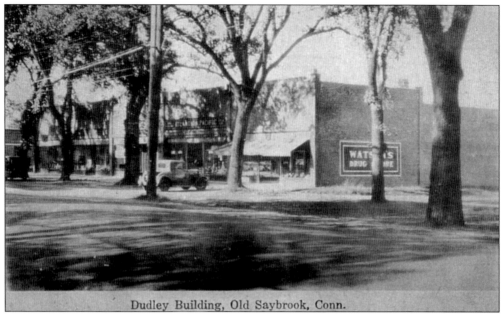

Dudley Building, Old Saybrook, Conn.

The Dudley Building on Main Street was constructed in 1927. It was, and still is, the home of Saybrook Hardware. Among the several businesses were the A and P Market, Dan Adanti's Bar and Grill, the Saybrook Liquor Store, the town's first radio and television store, a five-and-ten cent store, a dress shop, and a flower shop. Watson's Drug Store, shown at the end of the building, only sold packaged drugs. Prescriptions were only filled at James' Pharmacy or from Dr. Grannis, the town physician.

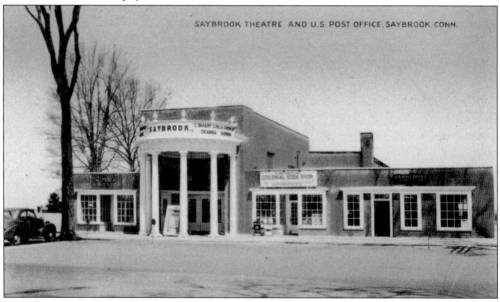

In 1937, Saybrook got a new Colonial-style theater with seating for 600 patrons. Movies were previously shown at the town hall. The following year, an addition to the building was filled by the U.S. post office, which joined Young's Soda Shop and Fred's Beauty Shop. A local resident recalls the first movie was *Elephant Boy*. The marquee shown here announces, *Smart Girls Don't Cry*, starring Deanna Durbin.

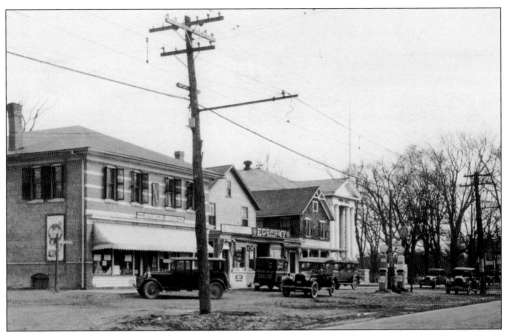

This view shows Tinner Smith's Stove Store, the Economy Market, the Gilt Edge, with the town's first gas pumps, and Stokes' Brothers food store. The Gilt Edge, a hamburger and soda type of restaurant, pool parlor, and gathering place, has been the source of some humorous stories passed down through local families.

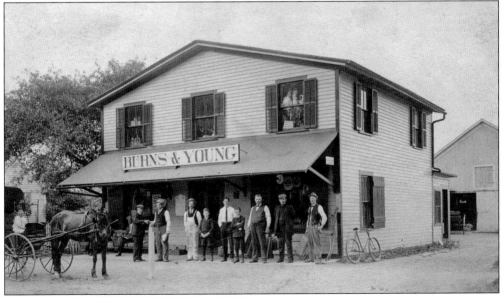

Robert Burns and Frank Young were enterprising clerks who began working in a store in North Cove. In the early 1900s, when ships stopped coming, they moved to the center of town and opened a general merchandise emporium. They sold candy, tobacco hung in strips from the ceiling, Lorna Doones, bread from Ward's Bakery, cheese, and tea from a bin. Dry goods, clothes, chamber sets, pots and pans, and other items were sold upstairs. Frank delivered orders with a horse and wagon, later an automobile.

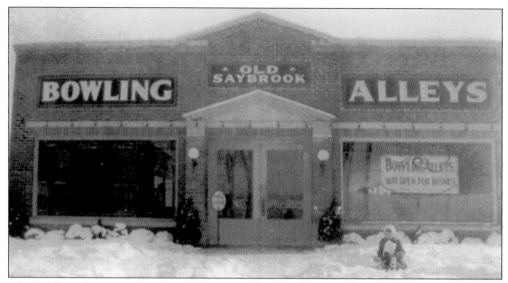

The bowling alley on Main Street was a popular spot for all ages. During World War II, bowling leagues competed, high school kids hung out, and boys earned money by manually setting up duckpins. Gas was rationed, and the alleys provided fun close to home. When the business closed, a furniture store served the local area. (Courtesy of Roy Lindgren.)

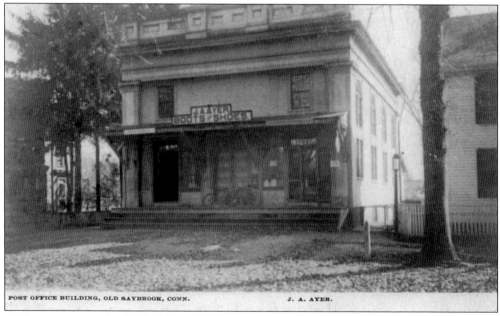

With a square steeple, this building was originally the Episcopal church and was located where the stone Grace Episcopal Church is now on Main Street. It was purchased by two businessmen who had the steeple removed and transported, by oxen power, around the corner to the Old Boston Post Road, where it has been a post office, boot and shoe store, meat market, bakery, and is now a dance studio. (Courtesy of Roy Lindgren.)

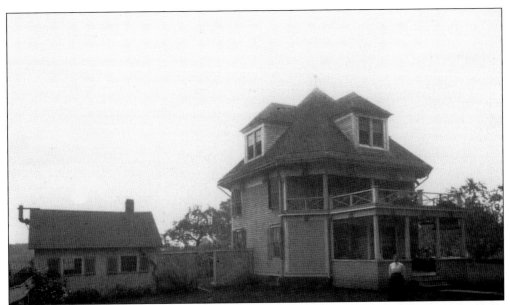

This unusual octagon house was a prefab building purchased and constructed by Horace Archer from the Sears and Roebuck catalog about 1890. It was the residence for many years of Robert Burns, partner in the nearby Burns and Young store. Today it is an office building. At one time, the town postmistress, Mary Burns, lived there. The lady on the postcard could be her mother.

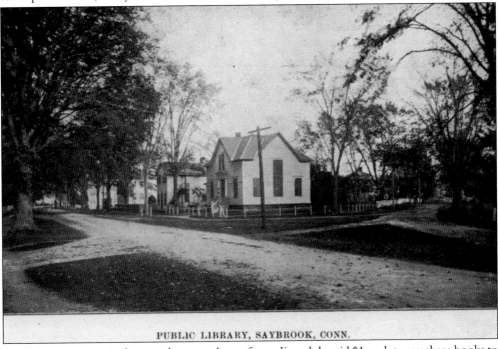

PUBLIC LIBRARY, SAYBROOK, CONN.

An early library service began when members of a reading club paid $1 each to purchase books to loan to others. In 1865, Harriet Willard was chosen as librarian, and books were moved to her house until 1871, when they were placed in a building owned by Thomas Acton. His summer residence was a large Colonial across the street called "Restholm." By 1873, the library had outgrown its facilities and moved to the building shown here and deeded to the town by Acton.

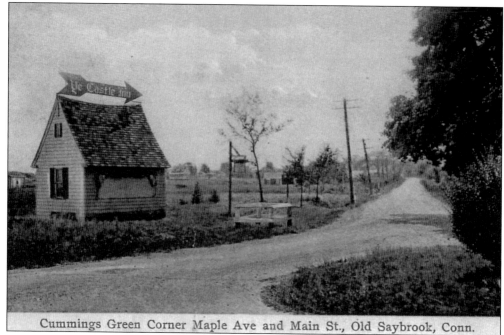

Cummings Green Corner Maple Ave and Main St., Old Saybrook, Conn.

At the corner of Main Street and Maple Avenue, this seasonal stand sold flowers, vegetables, fireworks, even crabs for bait. It stood alone on what is now a busy intersection but was formerly open fields. For tourists looking for the Castle Inn, this sign could not be missed, especially during Prohibition. (Courtesy of Roy Lindgren.)

This car dealership, with its gas pumps and fuel delivery operation, conducted a lively business. On the right is the corner of Sizer's Restaurant, the business that was formerly at Saybrook Point. To the left is a large Colonial house converted for commercial use. The building, slightly altered, is on Main Street. (Courtesy of Roy Lindgren.)

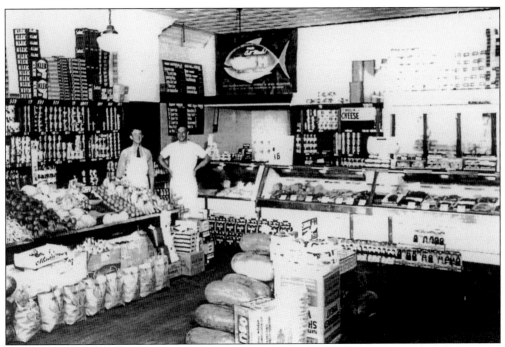

About 1940, the A and P Market moved into the Dudley building on Main Street, occupying a large center section of the structure. Under a tin-embossed ceiling, a large variety of food and household products were sold. Many high school students found work after school and on weekends, but not on Sundays when the A and P and most stores were closed. Among their tasks were stocking shelves, sweeping the wooden floors, and shoveling snow. (Courtesy of Roy Lindgren.)

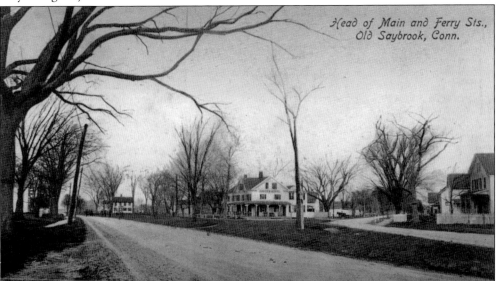

The Coulter House, now the Monkey Farm, is at the fork in the road. Main Street crossed the tracks at ground level. North of the tracks was the first Catholic church and cemetery and the first telephone office. On the right is the Whittlesey house, now Saybrook Country Barn. (Courtesy of Eugene Heiney.)

This building was north of the railroad tracks on what was known as North Main Street and was the home of the Southern New England Telephone Company. Local ladies worked the early switchboard, and so-called "party lines" were prevalent. The town did not move to a dial system until 1950. Telephone numbers were two or three digits. The Stokes' store was "10." A private residence was "272 – ring 3." The first conference calls were probably on party lines, like it or not. (Courtesy of Roy Lindgren.)

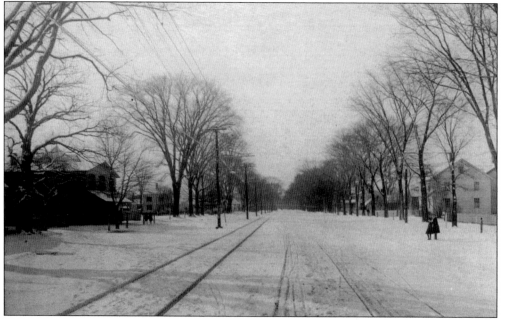

In the early 1900s, Saybrook was a quiet, peaceful town with a beautiful tree-lined Main Street. Trolley tracks are on the left, and sleigh runner marks—with the horses' hoofprints—can be seen on the right. Two warmly dressed young girls seem to be hoping for a sleigh ride.

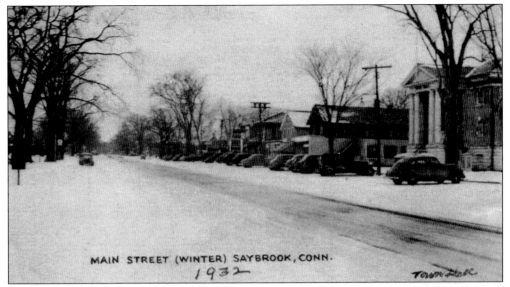

MAIN STREET (WINTER) SAYBROOK, CONN.

1932

After a snowstorm in 1932, the town center shows that Main Street has been plowed and businesses are in operation. The 1947 blizzard did close the town down with high drifts clogging the roads. Shovels sold rapidly at the local stores. Another heavy snow in 1982 caused Gov. Ella Grasso to close state roads. Some town officials made it to the town hall on snowmobiles, almost on time!

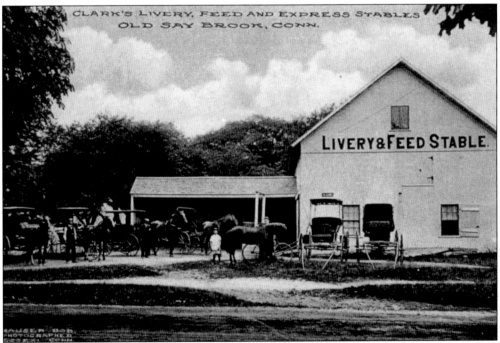

Old records show that horses, surreys, carriages, and freight wagons could be easily rented. A town census in the late 1800s records the population at 1,500 residents and 500 horses. By 1920, when their use had already been declining for several years, the average value of a horse was $165. Horses and oxen were available for heavy work—logging, moving buildings, and rolling heavy snow on local roads. (Courtesy of Roy Lindgren.)

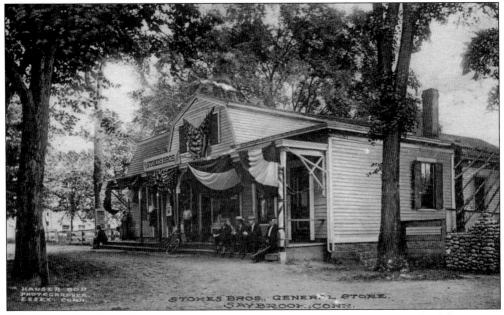

Stokes Brothers' store was first located where the early Bushnell store was, south of the present fire department. Residents gathered here to shop, talk, and possibly trade horses. The atmosphere was captured by local author Joe Cone: "A circle gathers every night, / Say twenty odd or more, / A round this big invitin' stove / In Stokes Grocery Store. / Nail kegs an' cracker barrels take / The place ov fine settees, / An' here the circle spends its time / In most luxur'us ease."

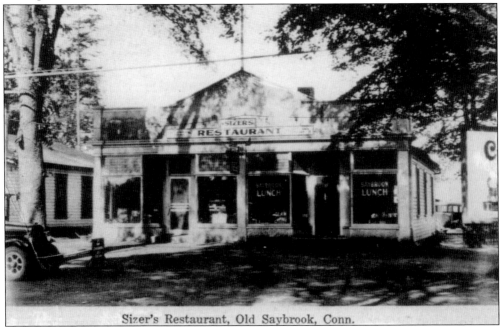

Sizer's Restaurant, Old Saybrook, Conn.

Sizer's Restaurant moved from Bridge Street to Main Street. The specialty was seafood. This building still stands on the west side of Main Street. Another well-known eatery across Main Street was Joe's Diner, an authentic-style diner. Joe Snead, the owner, was said to make the best rice pudding in town. That site is now the Penny Lane Pub.

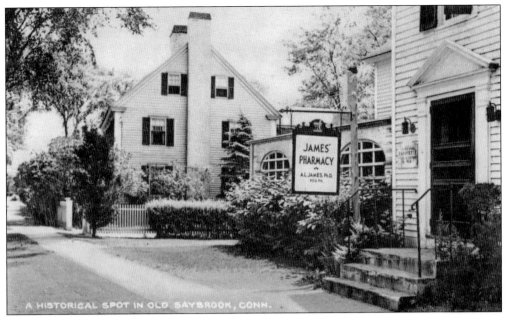

Peter C. Lane opened an apothecary and soda foundation in 1895. His sister-in-law Anna James became the first African American woman to graduate from Brooklyn College of Pharmacy (1908), and in 1910, became the first female African American pharmacist in Connecticut. James treated and advised local residents until 1967. The store was built in the early 1800s and is noted for General Lafayette's purchase in 1824, reportedly woolen stockings or saddle soap. (Courtesy of Robert Duncan.)

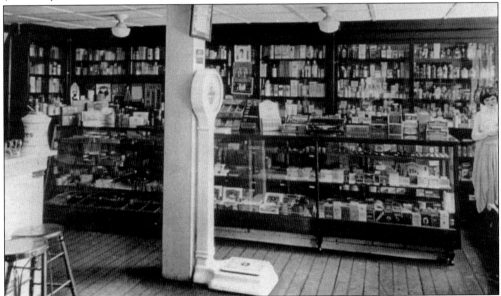

James Pharmacy retains the ice cream parlor, marble countertop, and antique chairs and tables. Miss James hired young men and women while still in school, and they learned good work habits ("never be late"). Ann Lane Petry, Miss James's niece, also worked at the pharmacy. She later became a noted author, publishing six books, including some based on her experiences living in Saybrook and the award-winning *The Street*. (Courtesy of Roy Lindgren.)

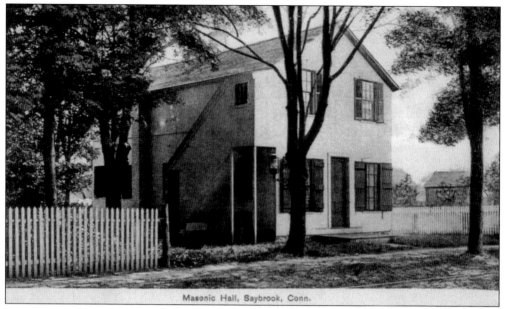

Masonic Hall, Saybrook, Conn.

The Masonic Hall, Siloam Lodge No. 32, was granted its charter in 1870. The building was first used as a carpenters shop for constructing the Congregational church. The shop was moved to a lot north of the old library, then again to its present location. Before it became the Masonic Lodge, Frederick Kirtland had a shoe store in the building. The fields and sheds in the background are part of the Pennywise Farm.

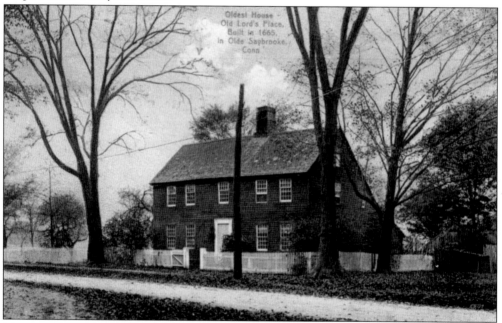

Oldest House -
Old Lord's Place,
Built in 1665,
in Olde Saybrooke,
Conn.

This 1665 home on Lord's Place was on the corner of old Boston Post Road and Lynde Street, across from the Masonic Lodge. William Lord fought in the American Revolution and was with Washington on his retreat across the Delaware River. Around 1930, the home was replaced with a Victorian-style house that is still standing. The road was gravel and narrow, but it became heavily used, as it was the only road west. It was a portion of Route 1, until the "cut-off" was built about 1930.

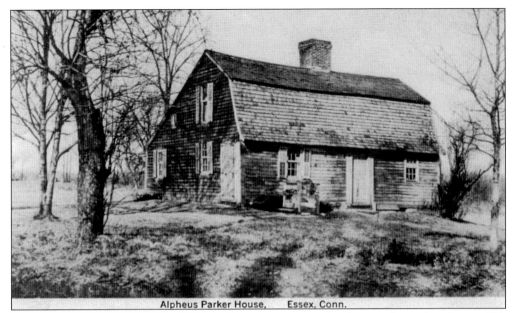

Alpheus Parker House, Essex, Conn.

Thought to be the oldest house in Saybrook, the Alpheus Parker house is located on Route 154, north of Route 9, and is incorrectly identified on this card as being in Essex. The Parker family was one of the first to build and farm several miles from the fort and Saybrook Point settlement. Many generations of the Parker family occupied the homestead. (Courtesy of Roy Lindgren.)

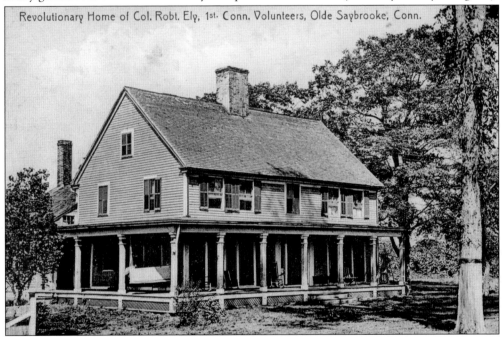

Revolutionary Home of Col. Robt. Ely, 1st. Conn. Volunteers, Olde Saybrooke, Conn.

This Colonial home at the intersection of Schoolhouse Road and the Boston Post Road, was the Revolutionary War home of Col. Robert Ely, First Connecticut Volunteers. The date of construction is unknown. No major battles were fought in Saybrook, but in April 1775, some 59 men went to help relieve patriots in Boston. Later, Capt. Seth Warner of Saybrook raised a crew of 110 seamen for duty in the Continental Navy.

49

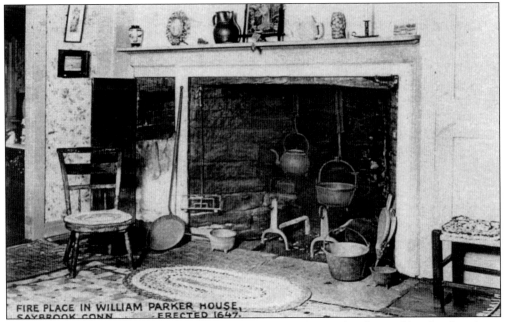

FIRE PLACE IN WILLIAM PARKER HOUSE, SAYBROOK CONN. ERECTED 1647.

The fireplaces of the early homes were needed for cooking and warmth. This working fireplace shows some of the original cooking utensils. Almost all early settlers owned a woodlot necessary for their several fireplaces, as well as for building homes, barns, boats, and fences. (Courtesy of Roy Lindgren.)

Patrick's Country Store, Est. 1931
288 Main St., Old Saybrook, Ct. 06475

Merle Patrick rode his old bicycle to his store, winter or summer. What he began as a dry goods store soon expanded to include practically everything—school supplies, newspapers, boots, and overalls. With the school next door, popular items included spearmint leaves, chocolate babies, jawbreakers, and root beer barrels. Students with good report cards received a free bag of candy, and on the last day of school, he would send lollipops for everyone.

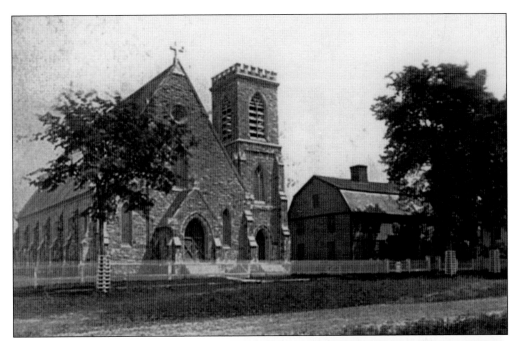

The first Episcopal church was a square wooden building constructed about 1830. It was moved around the corner to make way for the church now standing. The new building was constructed in 1871 of locally quarried granite. The fences around the trees kept horses from nibbling on the bark. The gambrel-style minister's home was later replaced with a large Victorian home, a copy of a house seen in England by Rev. Jesse Heald.

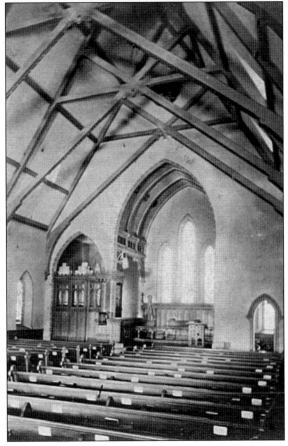

This view shows the interior of the Grace Episcopal Church. When constructed, parishioners donated beautiful lead glass windows. The arched window over the front entrance was given by a Hart family member. Elizabeth Hart Jarvis Colt, wife of Samuel Colt, was also a major contributor. The windows over the altar are original and face east to allow sunlight through the stained glass into the church.

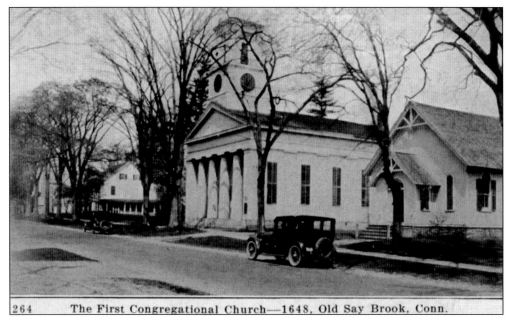

264　　　The First Congregational Church—1648, Old Say Brook, Conn.

The First Church of Christ (Congregational) got its start with services in the great hall of the fort at Saybrook Point. The Congregational church was the official instrument of government until 1818. Early Congregational churches were built on Middle Lane, now Church Street, and on the green opposite the present church, which was dedicated in 1840. Church service was called by the beating of a drum. Small, one-room buildings with fireplaces, called "Sabba Day Houses," were located on main roads leading to church, where parishioners could stop to warm themselves and fill foot stoves with coals.

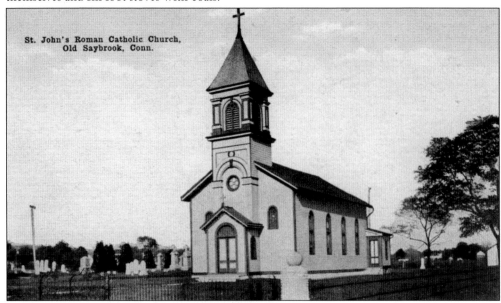

St. John's Roman Catholic Church,
Old Saybrook, Conn.

St. John's Roman Catholic Church is shown in its first location on the north side of the railroad tracks next to the Catholic cemetery. The building was originally used for manufacturing skates but, with renovations and a steeple, was converted to a church in 1864 and remained in use until 1931.

52

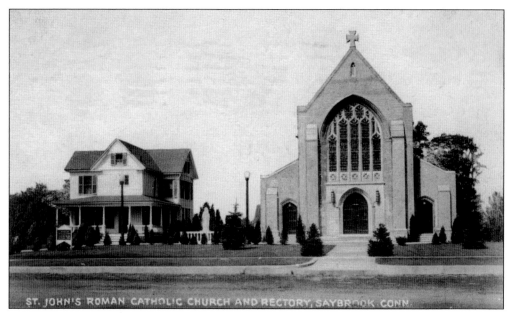

A new and enlarged St. John's Catholic Church was built on Main Street in the mid-1930s. Material salvaged from the old church was used to construct a parish hall behind the new one. Mrs. Anna Newcomb of Hartford gave the statue of Saint Theresa, which is made from Italian marble. A new rectory was built alongside the church.

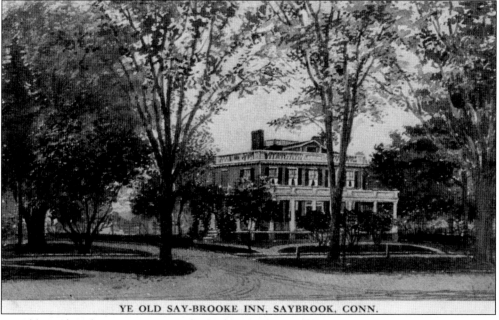

YE OLD SAY-BROOKE INN, SAYBROOK, CONN.

Ye Olde Saybrook Inn was previously the home of Capt. Ely Morgan, a wide-ranging seaman who commanded passenger ships between New York and London, the West Indies and elsewhere. Captain Morgan had many notable friends and among them was Charles Dickens, who stayed with Morgan while engaged in his American reading tour in 1867–1868. Not long after Captain Morgan's death in 1887, the home was purchased by H. C. Chapman, and then converted into Ye Olde Saybrook Inn. The inn was demolished in the mid-1940s.

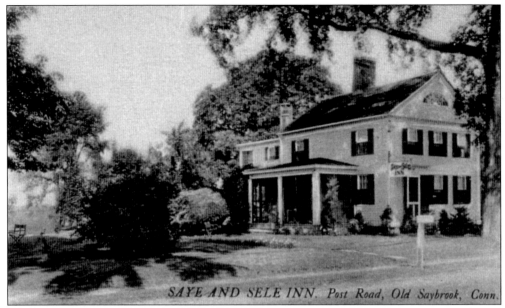

The Saye and Sele Inn was on North Main Street near Saybrook Junction. Constructed around 1815, this Greek Revival building was the birthplace of Maria Sanford (1836–1920), a graduate of New Britain Normal School and an English teacher at Swarthmore College. She became the first woman professor in the country in 1870. Retiring from there, Sanford went on to teach at the University of Minnesota until 1909. Since 1944, a statue of Maria Sanford has represented Minnesota in Statuary Hall in the U.S. Capitol as a pioneer woman educator. (Courtesy of Roy Lindgren.)

As an inn, this was a favorite of waterfowl hunters who frequented North and South Cove and the marshes along the river. Sportsmen could walk from the railroad station to the inn, and livery stables could provide transportation to the salt meadows where duck blinds were ready for guests. Many local restaurants served duck and geese in season, a favorite being duck breast sautéed in wild courant jelly and butter. (Courtesy of Roy Lindgren.)

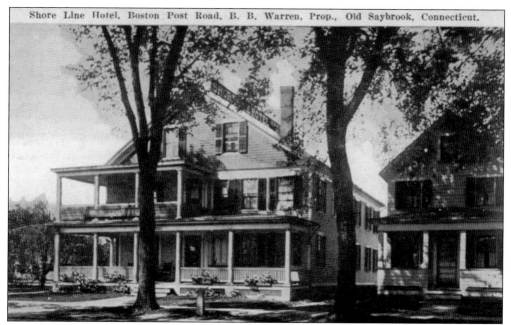

Shore Line Hotel, Boston Post Road, B. B. Warren, Prop., Old Saybrook, Connecticut.

The Shore Line Hotel was built in the mid-1800s and was owned by Barney Warren. Located on the Boston Post Road, it was the first mail stop for Old Saybrook. Being close to Saybrook Junction, it also profited from rail travelers who stayed there before heading to Saybrook Point for ship connections. The hotel was destroyed by fire in 1969 and today is the location of a large pharmacy. (Courtesy of Robert Duncan.)

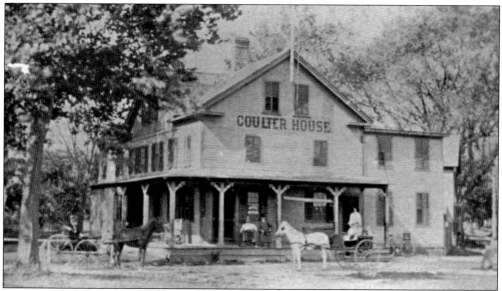

The Coulter House, used as a hotel beginning in 1892, was near Saybrook Junction and could accommodate 30 guests. With room and board costing $2 per day, it had a large flourishing patronage. In the early days, a livery stable was added to the house, and later, with changing technology, a garage for automobile-repair service, gas, and oil was added. In 1960, it was purchased by Tom Davies and Harry Corning and became a sports bar and is now known as the popular Monkey Farm.

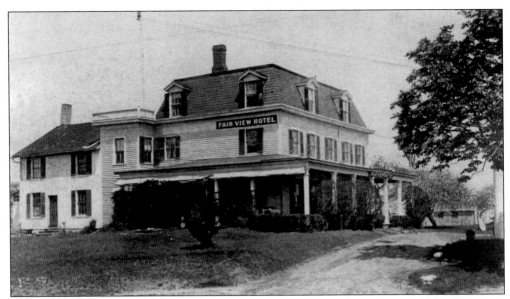

The Fairview Hotel was an imposing structure built in 1854 by Stillman Tiley of Essex. It was situated high on Kirtland's Rock near the ferry landing and had spacious views of the Connecticut River. Many notable guests signed its register. Some complained about the ferry; "most uncomfortable and unreliable dreadful," wrote one. After the opening of the bridge in 1911, and the end of the ferry service, the hotel slowly declined. In February 1926, a fire destroyed the entire building. (Courtesy of Roy Lindgren.)

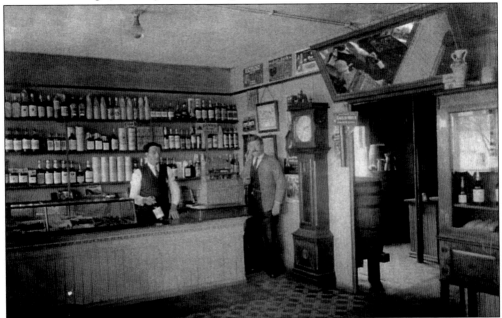

Spirit shops were often located at public inns. Prohibition brought a halt to legal sales of alcoholic beverages. Many stories from the Prohibition years indicate that local inhabitants did not suffer during the dry years. Stories of boats running across Long Island Sound empty and returning fully loaded to the numerous creeks and coves or shoreline points are well substantiated. (Courtesy of Roy Lindgren.)

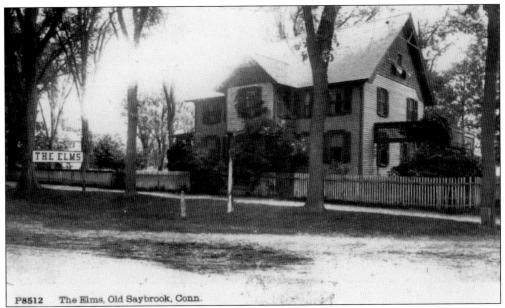

P8512 The Elms, Old Saybrook, Conn.

Samuel F. B. Morse attended Yale and studied electricity, mathematics, and science of horses, and later gained fame as an artist, inventor of the telegraph, and Morse code. The Morse family owned and lived in a house on the corner of Sheffield and Main Streets, described as "a beautiful old flower and vine covered house," built in the early 1800s. During demolition of the house in 1928, a handmade prototype brass telegraph key was found in the basement. The 100th anniversary of Morse's invention was celebrated with a special exhibit at the Acton Library in 1944.

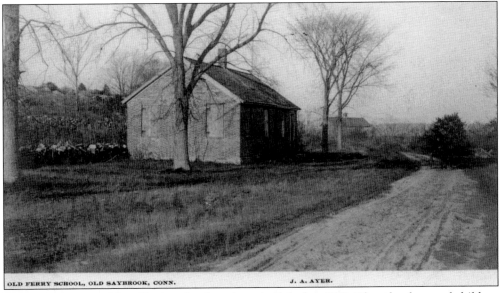

OLD FERRY SCHOOL, OLD SAYBROOK, CONN. J. A. AYER.

This school is one of four district schools and was built before 1763. The schools served children of all ages, from 9:00 a.m. to 4:00 p.m., five and a half days a week. Older boys were required to bring wood and set the fire. Girls had to sweep out during noon intermission. Boys were excused during the shad season and to harvest hay. There were 80 scholars registered at the Oyster River district school. District schools closed in 1892, and students attended the new consolidated school in the center.

The Saybrook Academy was built in 1831 on Main Street. It was a school for men with two large rooms, one on each floor. Teachers would receive pay that would often be supplemented with wood, grain, foodstuffs, and lodging. A number of private schools existed, and they were distinguished for their thoroughness and discipline. Young ladies were taught needlework, letter writing, religion, and English literature of Queen Anne's time. This building is now a private home on Cottage Place.

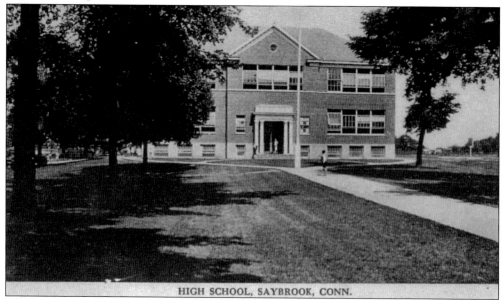

In 1936, this Georgian Colonial–style school on Main Street replaced the 1892 Consolidated School. Financed largely by Depression-era WPA funds, the building was designed to serve grades kindergarten through 12. Eight classrooms and an auditorium-gymnasium were located in the back of the building. As the population grew, new facilities were needed. A new junior high school was built on Sheffield Street, followed by the Kathleen E. Goodwin School on the old Boston Post Road, and in the 1960s, a new high school on the Boston Post Road. (Courtesy of Roy Lindgren.)

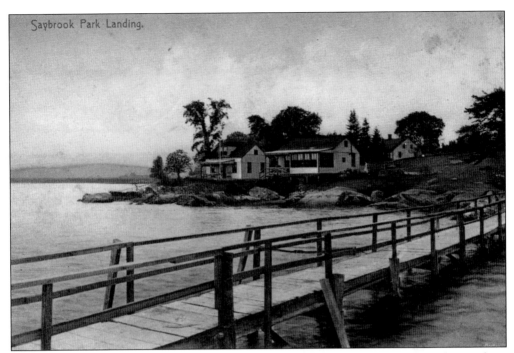

Saybrook Park Landing.

Saybrook Park was a summer recreational area on the Connecticut River. A natural cove along the west side of the river offered good swimming and fishing. Early seasonal cottages were built in the area. In the earlier days, shipyards built coastal schooners and sturdy rowboats. The name changed to Floral Park, and development increased in the 1930s.

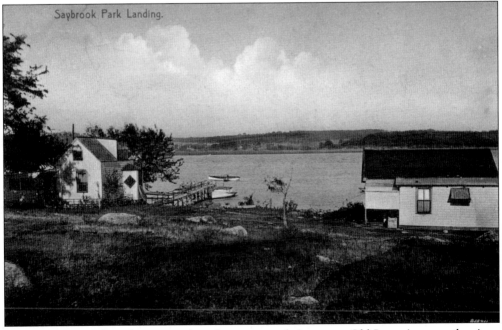

Saybrook Park Landing.

Recreation and fishing boats were kept in a protected river area. Old Lyme is across the river. Two of the early cottages are shown.

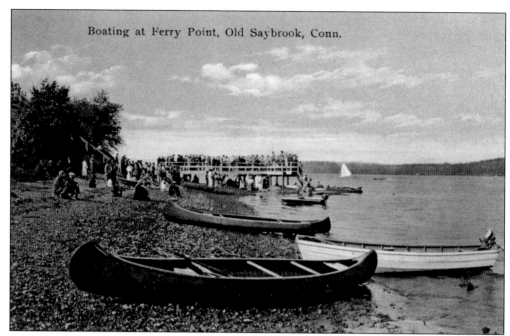

Boating at Ferry Point, Old Saybrook, Conn.

Areas along the river, except tidal marsh areas, were used for easy access to calm waters. Sailing, canoeing and boats with outboard motors are ready for the large group on the pier. Could they be tourists?

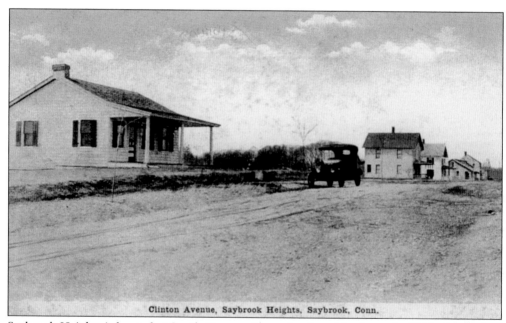

Clinton Avenue, Saybrook Heights, Saybrook, Conn.

Saybrook Heights is located at South Cove and was developed in the early 1900s. More than likely, the car shown here made the trip from an inland city, 40 or 50 miles distant and equal to three hours driving time, and longer when time to fix flat tires is added.

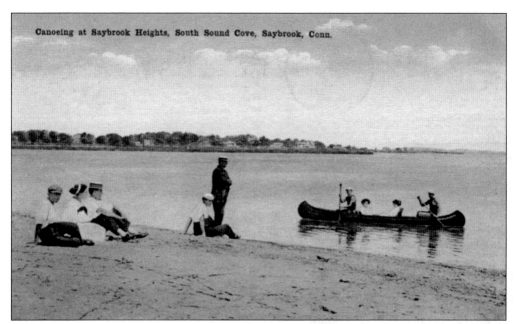

Canoeing at Saybrook Heights, South Sound Cove, Saybrook, Conn.

The South Cove area between Clinton Avenue and Soundview Avenue was a sandy beach. Seasonal homes lined both sides of the street. Early residents reported large blue crab catches. They also set eel pots and dug for clams. The cove was promoted as a safe place for children "and timid persons" to sail. The beach area has since become wetlands and today is designated as a biologically important ecosystem. (Courtesy of Roy Lindgren.)

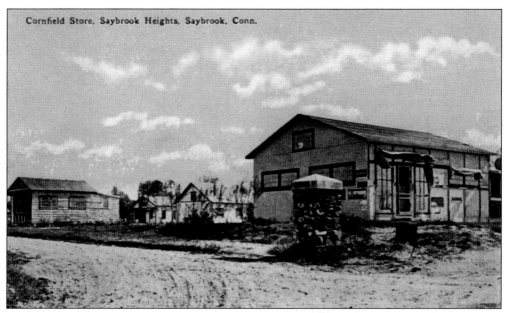

Cornfield Store, Saybrook Heights, Saybrook, Conn.

This early view is of Cummings Store, identified as Cornfield Store, on Maple Avenue. It served residents from Saybrook Heights and Cornfield Point for many years. The stone pillars remain today, although the early gas pump is long gone. (Courtesy of Roy Lindgren.)

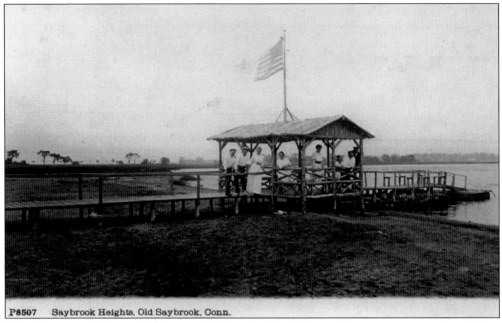

P8507 Saybrook Heights, Old Saybrook, Conn.

This pier, open shelter, and raft extended into the South Cove. Cottage owners on Soundview Avenue and Clinton Avenue constructed this waterfront facility for the Saybrook Heights residents. (Courtesy of Roy Lindgren.)

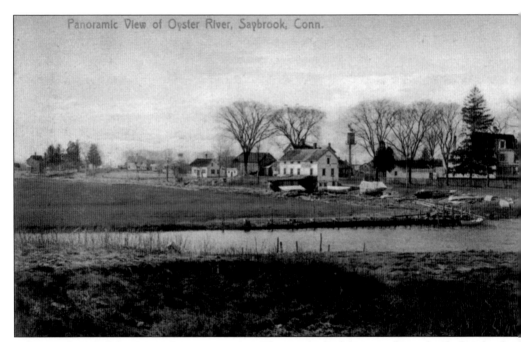

Panoramic View of Oyster River, Saybrook, Conn.

Life on and around the Oyster River was active. The area had salt hay meadows, fertile farmland, and valuable woodlands. There were lumber and grain mills, an ice-harvesting pond, dairy farms, ship building, and for a while, a soda-bottling company. In Saybrook's earliest days, a gristmill was located on the river. There were natural oyster beds but, for the most part, they

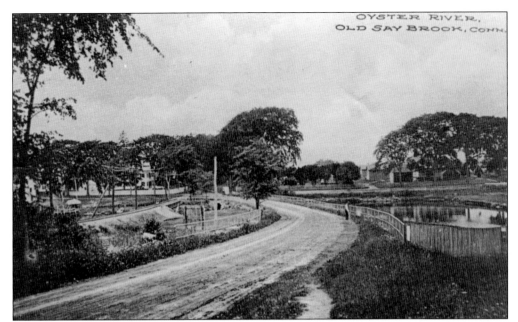

This view shows the Boston Post Road and trolley tracks and the bridges over the Oyster River. A boat-building facility is on the left and D. C. Spencer's large farm on the corner of Ingham Hill Road is on the right. The American elm trees are likely some of the 56 "centennial elms," one for each signer of the Declaration of Independence, that were planted throughout town to commemorate the national centennial in 1876.

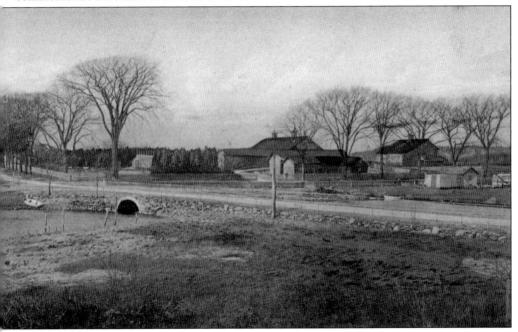

have disappeared, and recent efforts to replant oysters in the river have met with mixed success. The house in the center was built by H. C. Chapman and purchased by D. C. Spencer and moved across the street. This view shows the houses and barns on the Old Boston Post Road in the early 1900s.

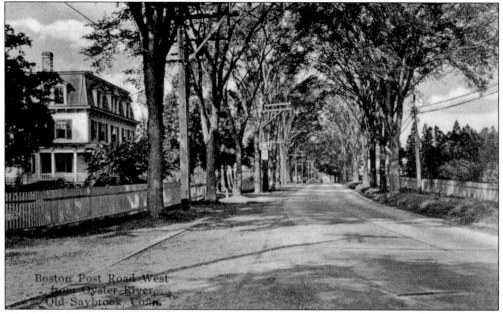

Boston Post Road West from Oyster River, Old Saybrook, Conn.

The Boston Post Road, with its tranquil archway of trees, made an inviting scenic route. All transportation passed this way—slow-moving oxen pulling loads of lumber, horses and carriages, hay wagons, the early stagecoaches, trolleys, and then the automobile. Much of history has passed over this famous Maine-to-Florida roadway.

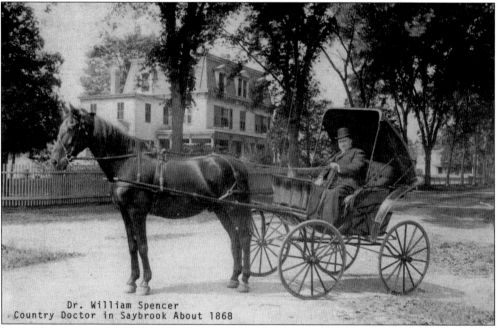

Dr. William Spencer
Country Doctor in Saybrook About 1868

Dr. William Spencer, son of Daniel C. Spencer, would have made house calls over all of Saybrook. The early roads were mostly cart paths, deep with snow in the winter and slick with mud in the spring. In the early 1900s, ninety-five percent of births took place at home. The leading causes of death were pneumonia, influenza, tuberculosis, diarrhea, heart disease, and stroke. Not an easy life for the doctor—or his horse.

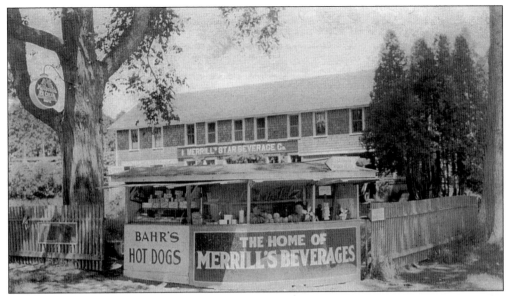

In the 1920s, this seasonal food stand on the busy corner served early cottage owners from nearby beaches. The sign on the arrow says Saybrook Manor, and on the inside wall are advertisements for "Moxie" and Millbrook Ice Cream.

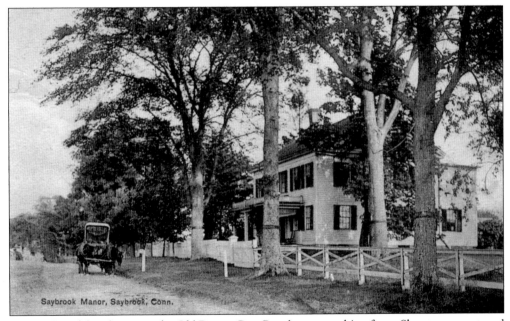

Saybrook Manor, Saybrook, Conn.

This Colonial farmhouse on the Old Boston Post Road was a working farm. Sheep were pastured on adjacent fields. Hay was harvested from the open acres of undeveloped areas near the beaches. Salt marsh grass was a valuable crop for cattle feed and garden mulch. At an earlier time, the stagecoach went past this farmhouse.

Cosey Nook Farm was one of the many along the Boston Post Road. This house, still standing, is at the intersection of Schoolhouse Road in the area known as Lord's Corner. Students from this area would take a school bus, drawn by two large horses, and later students would take the new Model T Ford school bus. If they missed the bus, they could always catch the trolley that stopped here.

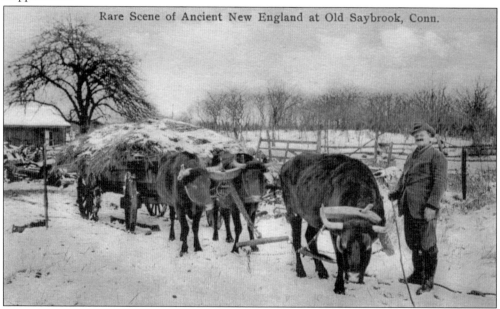

Oxen were indispensable to the early residents and were used to move buildings, plow rough ground, haul lumber down forest paths, even to turn the capstans to haul heavy shad nets to shore. Here Charles Strong has a three-ox hitch, which was unusual since they usually worked in pairs. Ox pastures confined the animals with stone walls built while clearing the land. Old brandy bottles have since been found tucked into the walls. Oxen needed little shelter and could be left at a pasture close to their working sites.

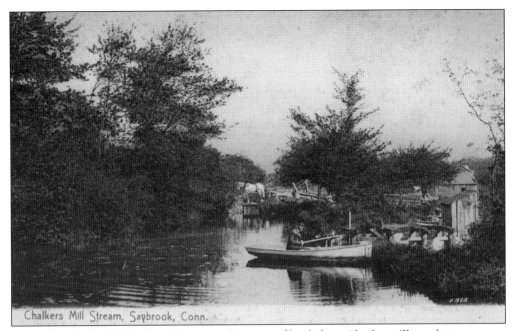

Chalkers Mill Stream, Saybrook, Conn.

Soon after the first English settlers arrived, a tract of land alongside the mill pond stream, near where Robert Chalker lived, was given to Frances Bushnell on condition that he erect a gristmill. Furthermore, it would be free from taxation as long as he kept it running for the benefit of the town. For many years, farmers brought their grain here to be ground.

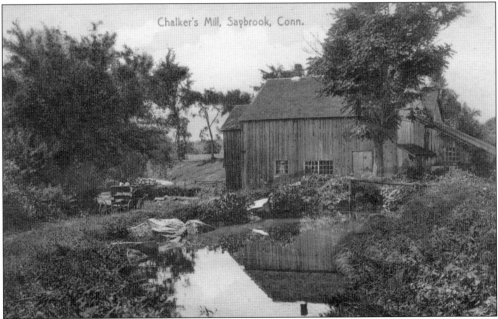

Chalker's Mill, Saybrook, Conn.

The mill pond was a favorite place for hunting, fishing, skating, and in more modern time, to enjoy the scenery. Here two friends in a horse-drawn carriage are enjoying a summer day, and the mill pond is shown in the distance. In the winter, ice from the mill pond was harvested and stored in a large, stone icehouse. It was packed in sawdust and sold to the railroad, hotels, and early beach cottage owners. In the late 1800s, ice was measured 6 inches thick.

This 1910 view shows Mr. Brooks with his ox team on land known in the early colonial days as the "Thousand Acres." Records show that crops were grown for the fort, animals grazed here, hay was harvested, and that fruit and berries grew on this open fertile acreage. Until recently, this was Frank Burton's Pennywise Farm on the old Boston Post Road.

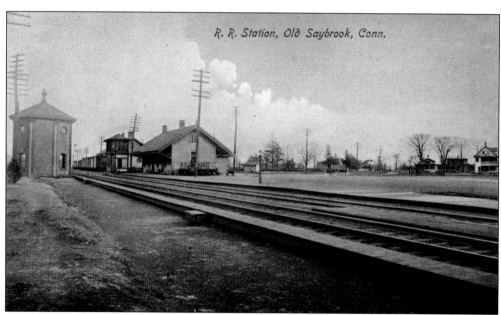

This early view of the railroad station shows just two tracks and no sidings. In the background is a boxcar waiting on the track to Saybrook Point. The manual switch tower is east of the station. The brick water tank (1873) held 26,000 gallons of water, raised by a steam-powered pump. As train traffic increased, a reservoir was dug and water piped to the tank. Diesel engines replaced steam about 1950.

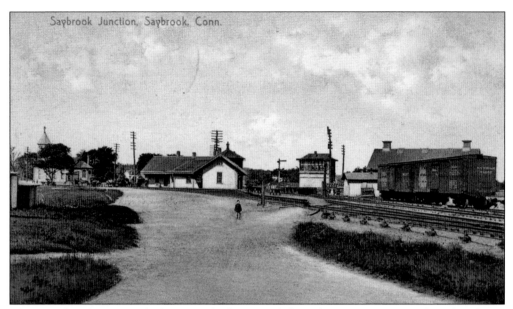

This is Saybrook Junction before 1911, looking north from the Boston Post Road. Saybrook was the center of shoreline transportation—the valley train from the north, the New York, New Haven, and Hartford Railroad from the east and west converged here. Sailing vessels and later steamboats on the sound and Connecticut River made Saybrook a destination. The Boston Post Road brought the mail and passengers on stagecoaches and later trolleys. Then in the early 1900s came the automobile.

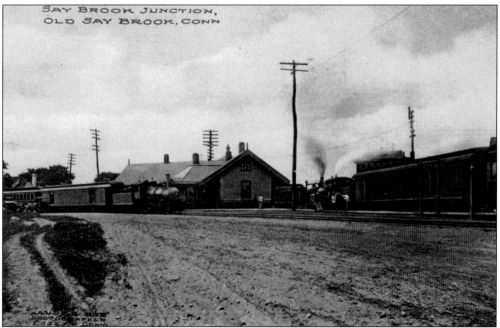

Two steam trains are shown leaving the junction, one to Saybrook Point and one to New London. Summer traffic was heavy on the rails. Southern fruits and vegetables were shipped north. Local mill pond ice was delivered to the station to preserve perishables heading to New London and points north. (Courtesy of Roy Lindgren.)

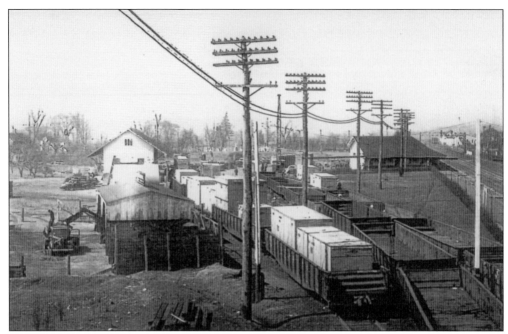

The Saybrook station was very active during World War II. The large wooden shipping crates were made in Old Saybrook and contained troop gliders that were made in Deep River. They would be sent to Boston for shipment to Europe. Coal brought in by gondola cars was stored on-site for local companies. Many very long trains passed through the station loaded with tanks, trucks, and guns pulled by multiple steam engines heading for East Coast ports. (Courtesy of Roy Lindgren.)

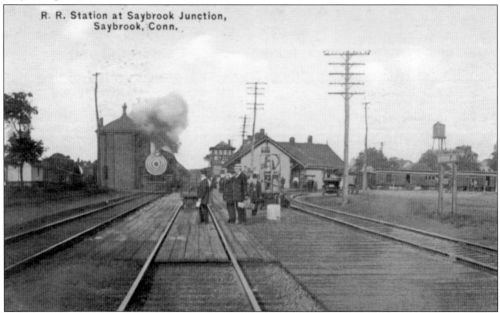

All Aboard! Next train leaving for Saybrook Point and Fenwick is shown on the track. The manually operated switch house is past the station to the right of the tracks. Horses and carriages and an automobile are parked on the grass. A steam train approaches from the east.

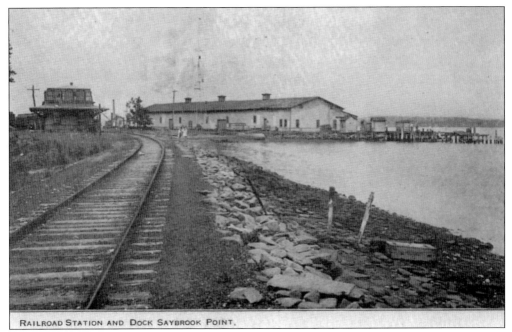

RAILROAD STATION AND DOCK SAYBROOK POINT.

The building on the left served as the Saybrook Point railroad station. The large freight house on the right stored goods coming in by boat or train. Large amounts of coal were stored at the facility for boats and trains. The tracks shown went to Fenwick across what is now the causeway. (Courtesy of Roy Lindgren.)

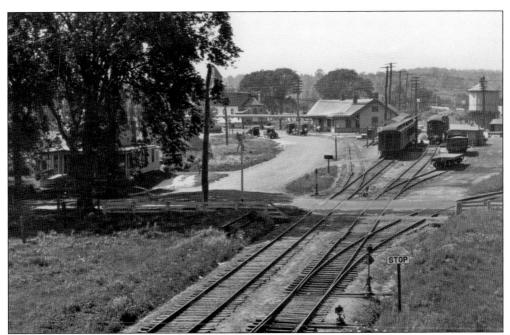

This view from the east shows the first St. Johns Roman Catholic Church and cemetery on the left. Cars are parked at the station. Middlesex Turnpike (North Main Street) and Boston Post Road crossed the tracks at ground level. Flagmen stopped road traffic.

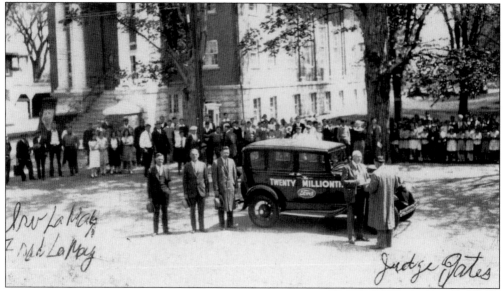

Just as steamboats were made obsolete by trains, the horse and carriage was quickly returned to the barn by the popularity of automobiles. Roads were extended and improved. Main Street was improved with hard-packed and crushed trap rock. This scene on Main Street, attended by schoolchildren and local citizens, celebrates the selling of Henry Ford's model T's and A's. Leading citizens headed up the occasion: Irving and Fred LaMay, who owned the facility, Merritt Chalker and Judge Gilman Gates, local officials, attended along with a Ford representative.

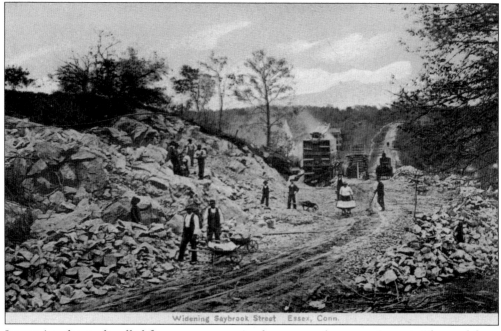

Improving the roads called for manpower, animal power, and new equipment. The road from Saybrook to Essex required cutting through hard rock. Modern machinery, hand labor, and even horses were employed for the difficult job. Once called Saybrook Street, this was an early Route 9 and is now Route 154.

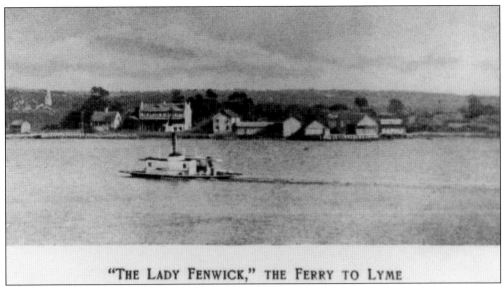

"THE LADY FENWICK," THE FERRY TO LYME

Ferry service across the Connecticut River was established by the General Court in 1662 and continued until replaced by a bridge for automobiles in 1911. The earliest route across was probably between Ragged Rock Creek (today known as Ferry Point) and the Lieutenant River in Old Lyme. Early ferries were powered by sail or horses on treadmills. Many drifted far from their designated landing spots. The Lady Fenwick was the first steamboat used for crossing and ran from about 1890 to 1905.

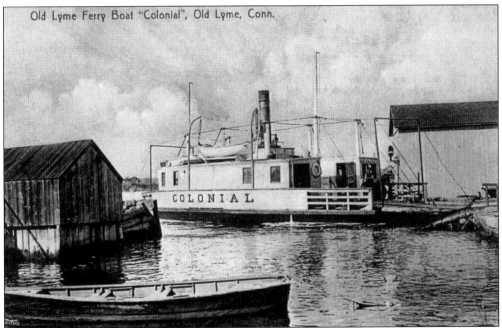

Old Lyme Ferry Boat "Colonial", Old Lyme, Conn.

The 55-foot-long Colonial transported passengers, automobiles, and cargo across the river from 1905 until it was struck by lightning and burned on June 16, 1911. During the summer, some 5,000 cars were ferried across the river. Jointly owned by Saybrook and Lyme, officials quickly launched a search for a replacement, but the only available ships were either too small or too large. The problem was permanently solved when the new bridge opened in August 1911.

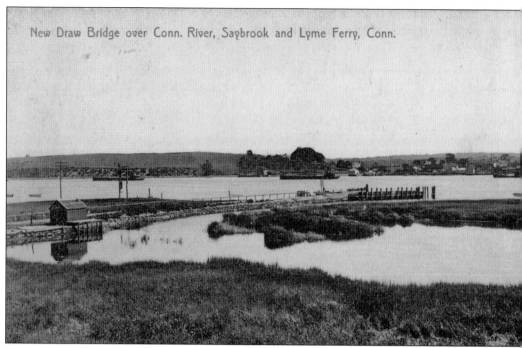

New Draw Bridge over Conn. River, Saybrook and Lyme Ferry, Conn.

Trains crossed the river by ferry since about 1850. The railroad cars would be pushed onto the ferry and brought to the other side where another locomotive was waiting. Overcoming great opposition from steamboat interests, the first railroad bridge was opened in 1871 and replaced with

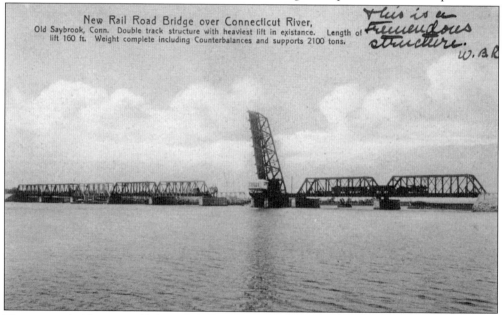

New Rail Road Bridge over Connecticut River,
Old Saybrook, Conn. Double track structure with heaviest lift in existance. Length of lift 160 ft. Weight complete including Counterbalances and supports 2100 tons.

this is a tremendous structure. W. B R

The present bridge was called a miracle of engineering in 1907. In its more than 100 years of operation, it has experienced many serious collisions and numerous bumps and bruises. It has also withstood severe hurricanes and record-breaking floods. During World War II, heavy war material was hauled by multiple engines pulling freight cars that reached from one bank to the other.

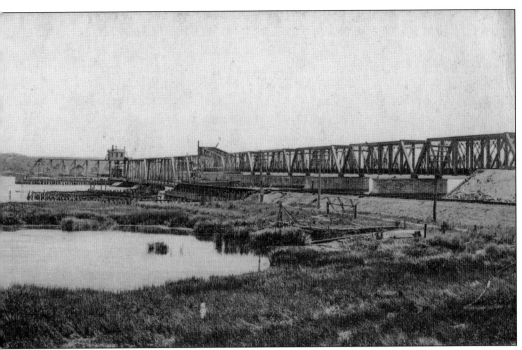

a swing bridge in 1889. A third bridge, still in use today, was opened in 1907. This panoramic view shows the 1907 lift bridge under construction.

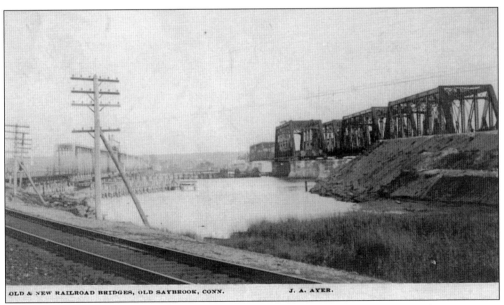

OLD & NEW RAILROAD BRIDGES, OLD SAYBROOK, CONN. J. A. AYER.

The New Haven railroad trains first traveled to New London on July 22, 1852, but it was not until years later when a bridge allowed them to easily cross the river. Before the bridge was built, the engine and cars had to be ferried across the river. Steamboat companies, local officials, and river men opposed constructing a bridge, because they feared it would interfere with river traffic. Finally, the railroad was able to construct a wooden bridge, which was replaced in the late 1880s by an iron bridge. (Courtesy of Roy Lindgren.)

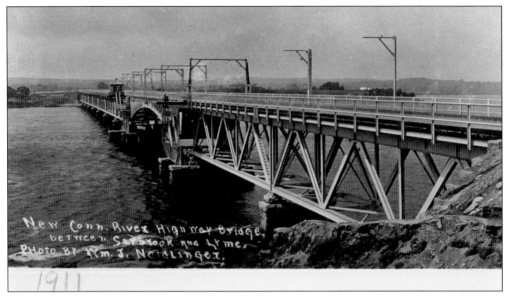

New Conn. River Highway Bridge. between Saybrook and Lyme. Photo by Wm. J. Neidlinger.
1911

The new bridge stretched 1,800 feet between riverbanks. The wooden plank bridge was 24 feet wide with provision for trolley tracks on one side. Captains of large sailing vessels complained of the delay in getting through the railroad drawbridge, but barges and tugs, and smaller power craft could easily pass under without trouble.

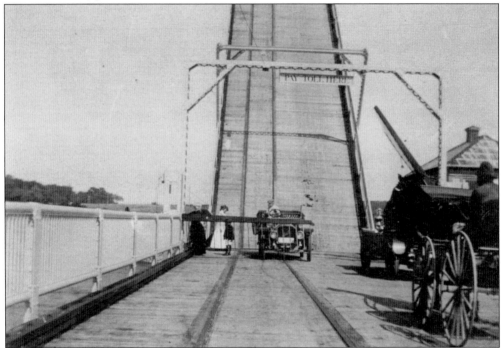

On August 11, 1911, the new drawbridge opened. Its roadway accommodated people, horse and wagons, automobiles, and had trolley tracks for the Shore Line Electric Railway. Saybrook and Lyme were connected and Route 1 from Maine to Florida had one less disruption. The toll was 5¢. For months, local residents came to the riverside to see the bridge open and close. With the lift up, travelers here are waiting.

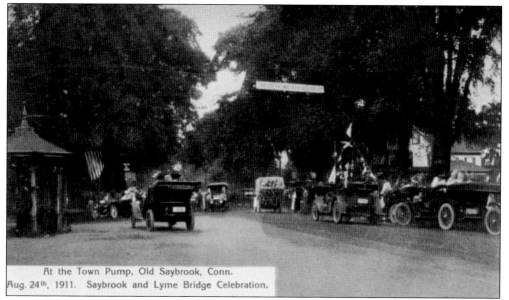

At the Town Pump, Old Saybrook, Conn.
Aug. 24th, 1911. Saybrook and Lyme Bridge Celebration.

A parade was held with decorated cars, marching units, and local citizens. It was led by a Saybrook car trimmed with American flags. Former governor Morgan Bulkeley, a Fenwick resident, was in the third car, decorated with wisteria vines. The year before the bridge opened, thousands of cars, trucks, and wagons crossed the river aboard the old Colonial ferry. There were 21,371 cars in all of Connecticut. The bridge was needed.

Daniel C. Spencer was a well-known local businessman and owner of a large farm along the Oyster River. His decorated car proudly sports a dirigible suspended overhead. Streamers, flags, ladies in long dresses and fancy hats, and children all scrubbed up showed how important the occasion was. Beginning in Saybrook, some 500 cars wound their way over the bridge into Old Lyme and back for the celebration parade.

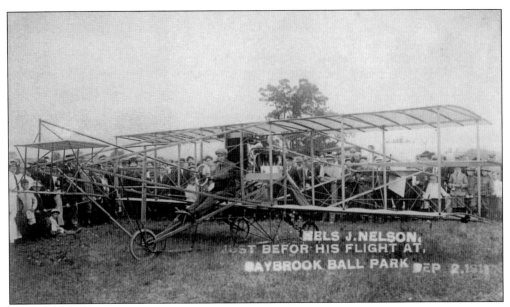

As part of the new Connecticut River bridge ceremonies, Nels J. Nelson flew his biplane from New Britain to the baseball field in Old Saybrook. In a flight on September 2, 1911, before 2,000 spectators, "he tilted his plane and glided upward like a bird." However, his radiator cap flew off and broke the propeller, and he came down rapidly and crashed into a fence, but was unharmed. (Courtesy of Roy Lindgren.)

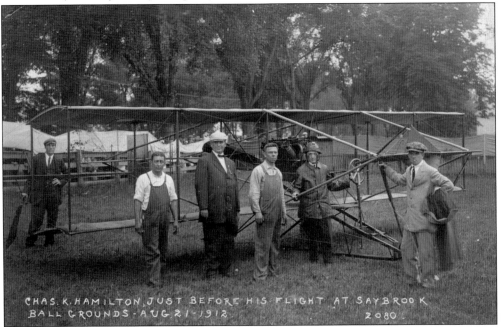

Another airplane flight from New Britain to Old Saybrook was made by Charles K. Hamilton. A New Britain resident and popular daredevil pilot, Hamilton was perhaps America's best-known flyer at the time and the first to make a round-trip flight between New York and Philadelphia. His plane was on display on the baseball field on August 21, 1911. He and Nels Nelson were aviation pioneers who drew large crowds who came to see their wondrous machines.

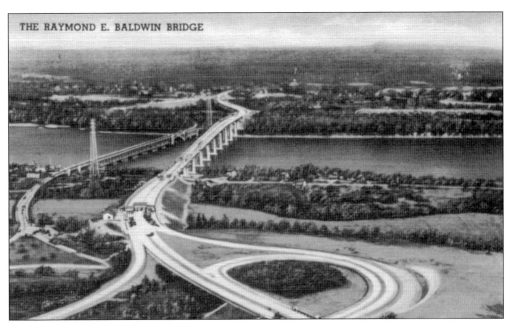

The 1911 drawbridge, with its narrow two lanes and frequent opening for river traffic, caused many delays. A new bridge with a four-lane divided highway was constructed and dedicated on December 4, 1948. It was 85 feet above the water. The 10¢ toll remained for 20 years and was collected on the Saybrook side. The bridge was named for Raymond E. Baldwin, who served as governor, U.S. senator, and chief justice of the state supreme court.

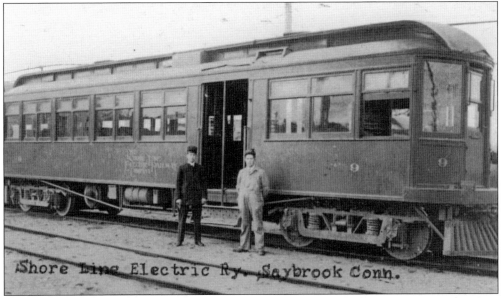

The Shore Line Electric Railway unsuccessfully attempted to compete with automobiles and the New Haven Railroad and operated between 1910 and 1919. A carbarn was located in Saybrook and another in Guilford. In Saybrook, the line ran close to the Boston Post Road and continued to Main Street with many stops. After the drawbridge opened, it went through to New London. Summer beach residents could ride to Saybrook shops, the library, or the Consolidated School on Main Street. (Courtesy of Roy Lindgren.)

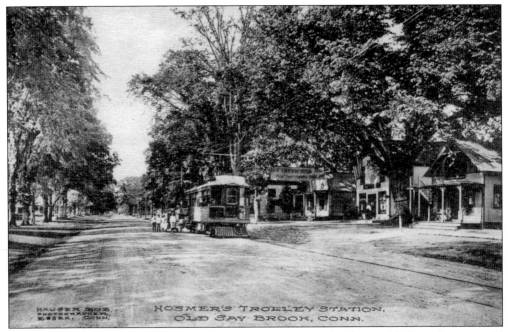

HAUSER BOB,
PHOTOGRAPHER,
ESSEX, CONN.
HOSMER'S TROLLEY STATION,
OLD SAY BROOK, CONN.

To school on the trolley! At the end of the 19th century, a mother busy with farm chores would call out, "Samuel, Henry! Get your slates and lunch pails. The trolley is coming!" Saybrook students rode the trolley to the Consolidated School on Main Street. Although our ancestors often told of walking to school "uphill in deep snow both ways," the trolley made the journey easier than walking or hitching the family horse.

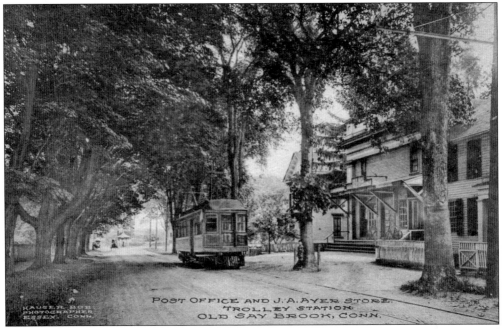

HAUSER BOB,
PHOTOGRAPHER,
ESSEX, CONN.
POST OFFICE AND J. A. AYER STORE,
TROLLEY STATION.
OLD SAY BROOK, CONN.

Townspeople were successful in seeing that the trolley route was "of the greatest advantage and the least injury to the town." The trolley might have stopped at the post office, at shops, and perhaps at the town pump, which can be seen in the distance with a horse-drawn carriage.

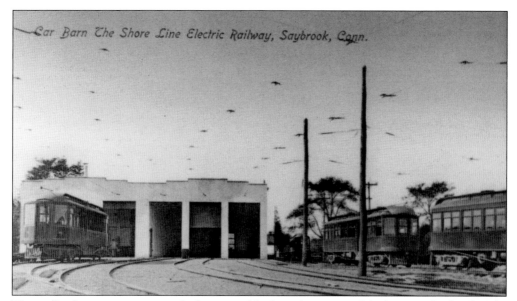

Car Barn The Shore Line Electric Railway, Saybrook, Conn.

The trolley barn was constructed of concrete blocks and was one of the largest of its kind in the state, 190 by 74 feet. When being constructed, in April 1910, it collapsed, killing one worker and injuring several others who were taken on the morning train to the New Haven Hospital for treatment. The barn was located at Saybrook Junction, near the railroad tracks (now Ford Drive). The trolley houses were built nearby for workers and their families.

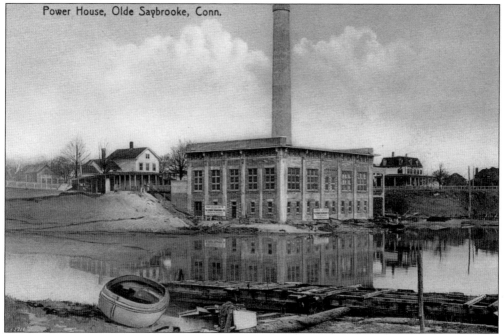

Power House, Olde Saybrooke, Conn.

The powerhouse for the trolley was located at Ferry Point and generated electricity needed to keep the trolleys moving. Constructed of reinforced concrete, the building housed two large boilers that powered turbine engines. It was a favored drop-off point during Prohibition. In recent years, it has been a boat maintenance facility. Its landmark chimney rises 230 feet and continues to draw curious viewers today.

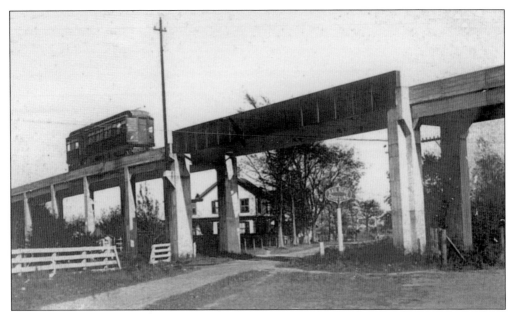

The elevated track on River Street, shown here, allowed the trolley to pass over the railroad tracks to Saybrook Point. The trolley cars were manufactured by the Jewett Company, Newark, Ohio. They were painted a dark green with gold letters identifying them as, "The Shore Line Electric Railway Co."

Old Saybrook residents eagerly awaited the first trolley when it left the barn on August 26, 1910. "People living on the stretch through which it passed," they wrote, "watched it with far more interest than they would have a circus parade." Several of the workers lived in these "trolley houses" near the trolley barn. (Courtesy of Roy Lindgren.)

Three

ALONG THE SHORE

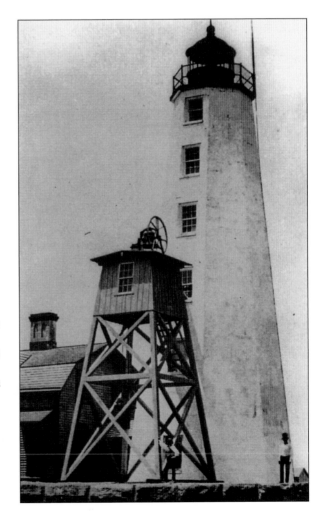

This lighthouse marks the entrance to the Connecticut River and serves as a navigational aid for ships on Long Island Sound. An earlier light was not tall enough to be seen and was often obscured by mist from the nearby marshlands. It was replaced in 1838 by this 65-foot granite structure, now called the Lynde Point Lighthouse or Inner Light. Old Saybrook is one of very few communities that has two lighthouses within its borders.

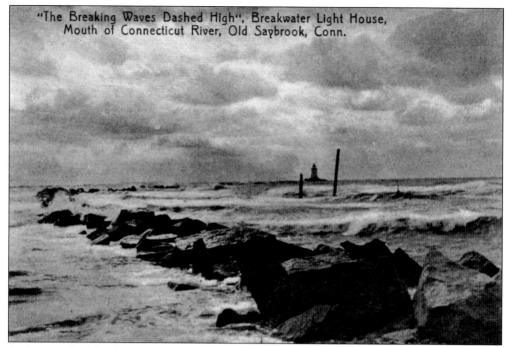

"The Breaking Waves Dashed High", Breakwater Light House, Mouth of Connecticut River, Old Saybrook, Conn.

At the mouth of the Connecticut River, a shifting sandbar was an obstacle to shipping. Although there was a fishing industry and wharfs for trading goods from other ports, Saybrook never became a major city. In 1802, the U.S. government purchased an acre of land from William Lynde, and on a stone foundation constructed a 35-foot-high shingle-covered wooden lighthouse with a whale oil lantern that began signaling on August 17, 1803.

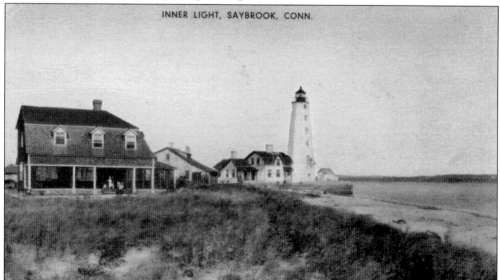

INNER LIGHT, SAYBROOK, CONN.

After the breakwaters were completed, the Lynde Point Light was also referred to as the "Inner Light," while the Breakwater Light was known as the Outer Light. A Fresnel lens that was installed in 1890 remains to this day. Kerosene replaced whale oil fuel in 1879. Electricity probably came to the Inner Light soon after it was introduced to nearby Fenwick in 1915. With today's bulbs and prisms, light can be seen up to 14 miles away.

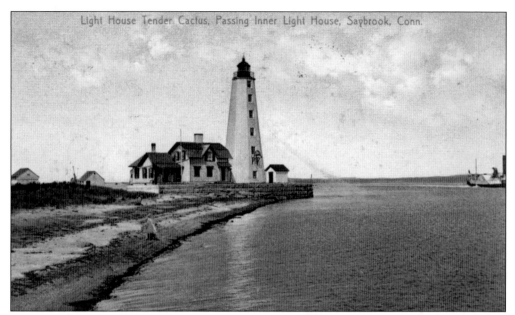

Life at the Inner Light was perhaps better than most lighthouses. The keeper and his family enjoyed a six-room frame house. Lawrence Gildersleeve, whose father, Elmer, was the keeper, was born in the lighthouse in 1906 and recalled passing time by playing cards, listening to the phonograph, or watching the ships go by. He sometimes fished and had the exciting diversion of being able to caddy in the nearby golf course.

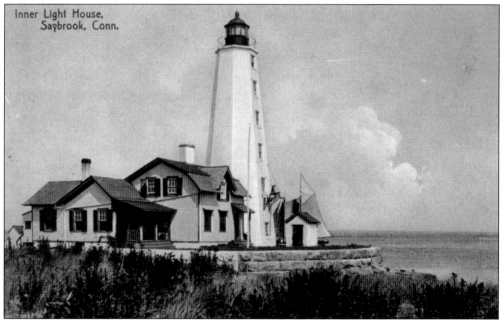

From the lighthouse, early keepers could view ships crossing the sandbar into the river, a dangerous undertaking before the breakwaters were constructed in the 1880s to maintain the channel. Warnings were given by ringing a large bell, which was later replaced by a foghorn. In 1973, that was replaced by a whistle, and more recently, with radio frequency. The familiar two-tone foghorn was sadly missed by many shoreline residents.

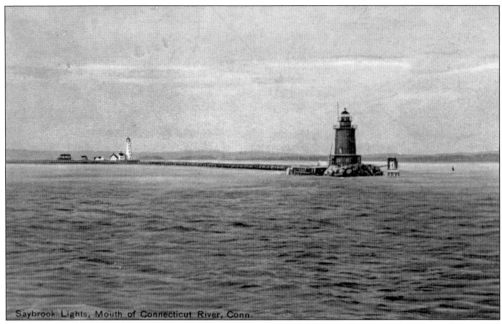

Saybrook Lights, Mouth of Connecticut River, Conn.

To accommodate a growing number of steamboats, the U.S. government, in 1870, began dredging the river to create a channel 8 feet deep by 100 feet wide at low tide. By constructing two parallel stone breakwaters, they hoped to confine the shifting sandbar and keep the channel open. Tons of rock was dumped, and the jetties were completed by 1880. A cast iron light station at the end of the west jetty, the Outer, or Breakwater Lighthouse, was established and first lit in 1886.

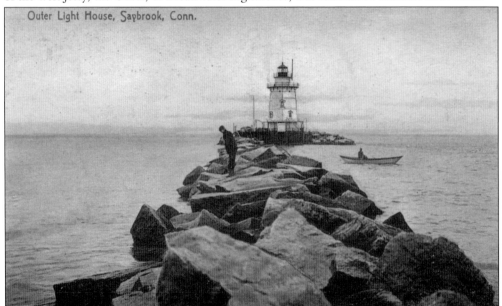

Outer Light House, Saybrook, Conn.

In addition to attempting to control the shifting sandbar, the breakwaters mark the entrance to the Connecticut River. The Outer Lighthouse, a five-floor structure, has an engine room, a kitchen on the second floor, a living room on the third, a dormitory-style bedroom on the fourth, and is topped by the lantern on the fifth floor. Since 1940, the U.S. Coast Guard has operated both lighthouses.

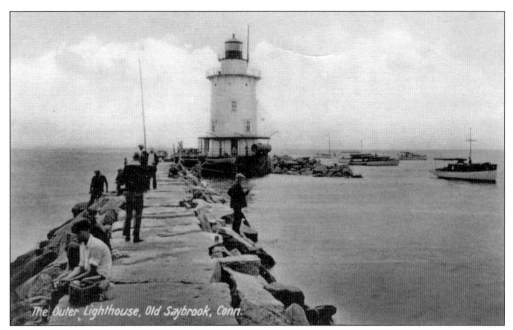

The Outer Lighthouse, Old Saybrook, Conn.

Of all the fish in Saybrook waters, none were as common or as important as shad. Coming through the water in great waves, they were caught in large mesh seines, brought to sheds for salting, and then shipped for trade. Shad season began in early spring and remained open until the run was over—a matter of a few weeks. In the 1940s, the first shad caught was ceremoniously presented to the governor.

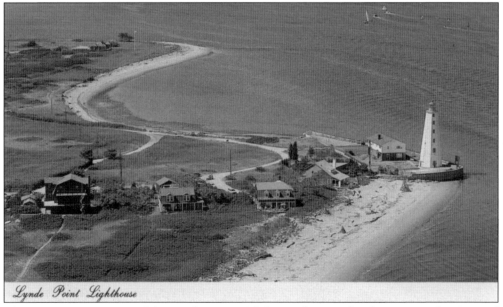

Lynde Point Lighthouse

This contemporary view of the Lynde Point Lighthouse shows its key location on the river and sound. Bordered by exclusive summer cottages at Fenwick, neither the road nor the lighthouse, itself, are open to the public. In 1993, Connecticut issued special "Preserve the Sound" license plates featuring this lighthouse. In 1990, it was placed on the National Register of Historic Places, and in 2007, was placed on the National Historic Lighthouse Preservation list.

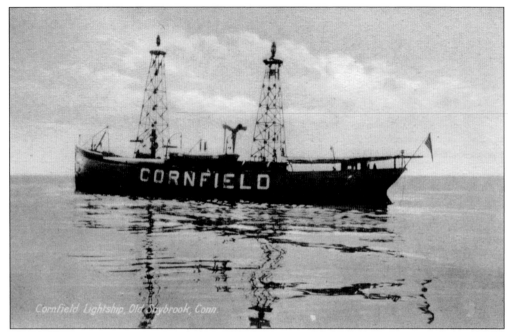

Lightships guided vessels around Cornfield Point from 1856 to 1957. This all-steel red ship with white lettering had two lamps, each providing 15,000 candlepower and an alternating fog signal of a bell and horn. The vessel remained in service until 1957 and was last reported to be slowly decaying in a mudflat in Lewes, Delaware. Efforts to raise funds to return her to Old Saybrook have been unsuccessful.

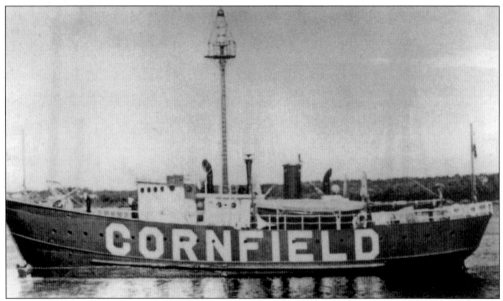

This early ship was rammed by a barge and sunk in 1919. Ironically, it was the first lightship fitted with electric lights. The lightship crew quickly boarded lifeboats and were picked up by a tug and brought to New London. No lives were lost, and no personal property was saved. The LV-51 rests in 180 fathoms of water and is the state's first Underwater Archaeological Preserve. (Courtesy of Roy Lindgren.)

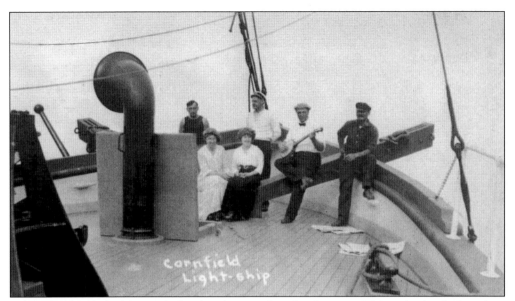

Life on board a lightship was isolated and exposed to the elements. Visitors broke the boredom and were a cause for merriment. On board there was a cook's gallery, space for the crew, and staterooms for the officers. Grocery orders were radioed to the Saybrook Point Lighthouse, which then forwarded orders to the local grocery store. The monotony of three weeks on board was broken by shore leave, often spent at the great bar at the Pease House. (Courtesy of Roy Lindgren.)

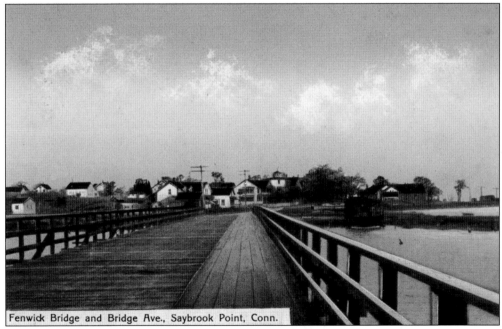

Fenwick Bridge and Bridge Ave., Saybrook Point, Conn.

Prior to the existence of the bridge from Saybrook Point, the only road to Fenwick was a cart track, now Maple Avenue, through the pastures around Cornfield Point. Deep dust and aggressive mosquitoes encouraged another route. A wooden bridge, five-eighths of a mile, was constructed with a walkway and planks that rumbled as carriages passed over them.

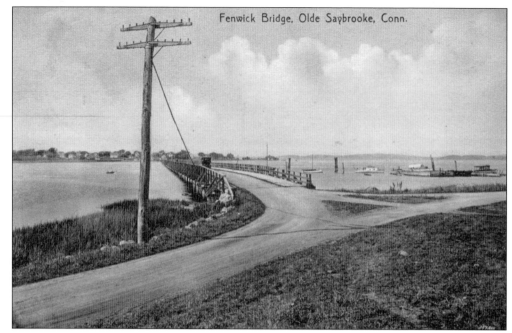

Fenwick Bridge, Olde Saybrooke, Conn.

After several years, the Fenwick Bridge was in need of repairs. Fenwick claimed it was the town's responsibility to repair it. The town claimed it was a private road and a task for Fenwick to repair. Edward Stokes, proprietor of Fenwick Hall, tore up sections of the roadway to prevent travelers from using it and risking legal action. The court finally ruled that it was a public highway and the town's responsibility.

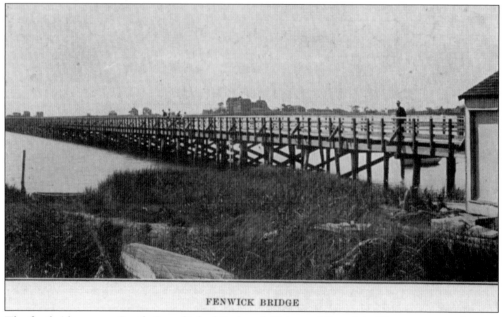

FENWICK BRIDGE

The footbridge across South Cove linked Saybrook Point and Fenwick. The person starting out here is walking toward Fenwick. The large building in the distance is Fenwick Hall, Connecticut's most luxurious hotel. Tides and time are slowly taking their toll on the bridge pilings, although remains of some can still be seen at low tide today.

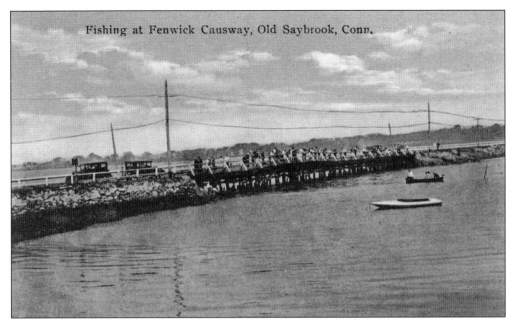

After the railroad to Fenwick was discontinued in May 1916, the railroad right-of-way was paved and a causeway constructed for automobiles. A straight and narrow half-mile stretch crosses South Cove, earlier called "a beautiful little bay." The roadway and its shoulders have long provided a prime location for fishing, although the Cove's shallow waters were best for yielding eels, blue crabs, and snapper blues.

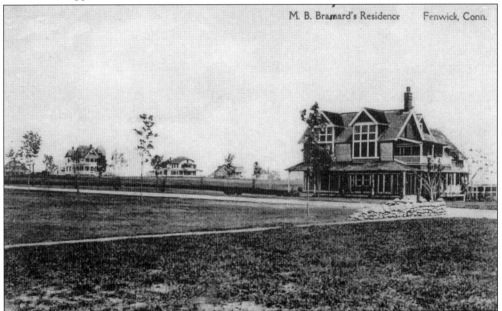

M. B. Bramard's Residence Fenwick, Conn.

In the summer of 1870, several prominent Hartford families came to Old Saybrook looking to establish a summer resort that would be easy to reach with the opening of the new Connecticut Valley Railroad. Before the opening of the railroad, they purchased several hundred acres along the Connecticut River and Long Island Sound and formed a joint stock company to sell lots, called New Saybrook. (Courtesy of Roy Lindgren.)

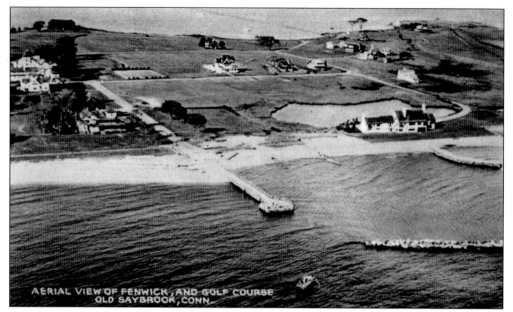

Of all the cottages at Fenwick, perhaps the most private is the one shown here on the narrow spit of land between the pond and the sound. Formerly the home of actress Katharine Hepburn, "Kate" and her sisters and brothers enjoyed swimming, boating, tennis, golf, and social events as children and returned each summer as they grew older. Hepburn, who treasured her privacy, was, and remains, the major attraction for casual visitors to the area. (Courtesy of Roy Lindgren.)

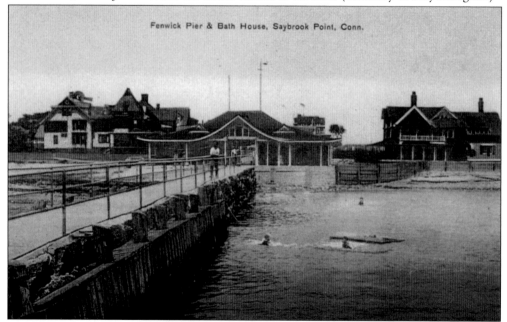

The beach at the pier was not agreeable to several residents, and a sandy, shallow area west of the breakwater was selected for a new beach. The bathing house was moved there. It was a dimly lit building with a long row of rather dingy and sandy cubicles. Moving the beach proved unsatisfactory, and it was seldom used. After a few years, the bathhouses were moved back near the convenience of the pier. (Courtesy of Roy Lindgren.)

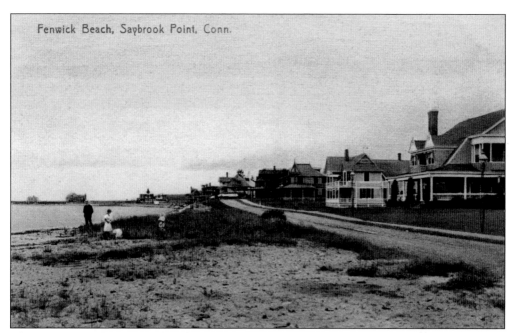

Fenwick Beach, Saybrook Point, Conn.

Claims made in the original brochure promoting Fenwick said the bathing beach was of "fine sand and of very gradual slope." The surf was not as grand as the ocean, the brochure stated, but it was also not as dangerous and was "free from the dreaded undertow." For the most part, however, it was small and stony with unforgiving eelgrass.

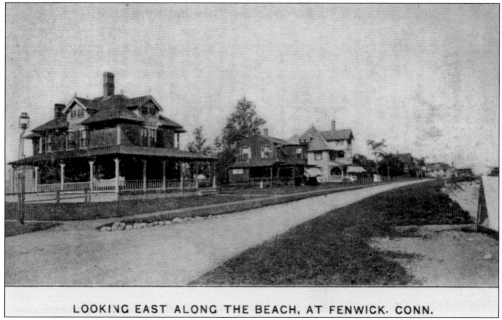

LOOKING EAST ALONG THE BEACH, AT FENWICK, CONN.

This view shows Fenwick Avenue, about 1890. Lots were originally sold in New Saybrook by auction with a premium bid for those near the hotel, where it was expected people would have their meals. Shingled cottages were eventually constructed, giving a combination rugged and refined character to the community. Many houses were Victorian with large and rambling architecture incorporating porches and towers.

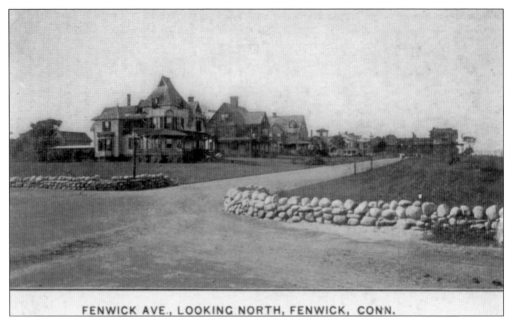

FENWICK AVE., LOOKING NORTH, FENWICK, CONN.

Cottages had no running water. As one early resident explained, "Every drop of water we used was pumped by the maids and carried to the various rooms." Later pumps were powered by windmills. Water service and hydrants were not installed until 1985. Light was from oil lamps or candles, and roads were marked by a few oil lamps on wooden posts. The lamplighter made his rounds with a dedicated band of youthful followers watching his every move.

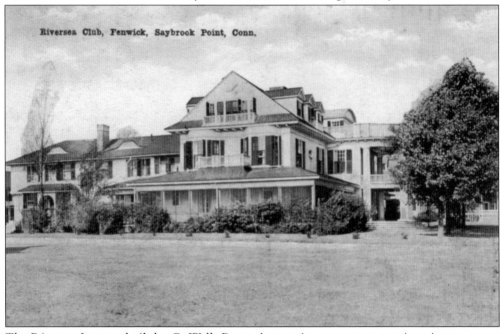

Riversea Club, Fenwick, Saybrook Point, Conn.

The Riversea Inn was built by G. Wells Root. Among its guests were motion picture actress Gloria Swanson and other actors and actresses playing at the nearby Ivoryton Theater. In 1946, it was purchased and renovated, and in 1957, purchased by borough residents, rezoned to residential, and sold as a private residence.

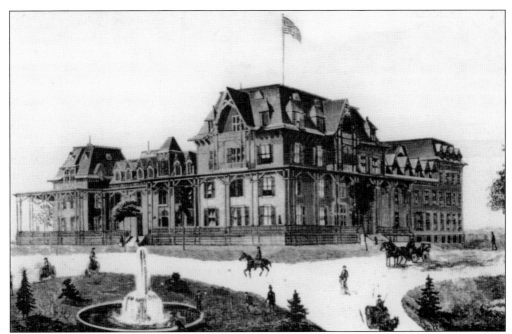

Facing Long Island Sound, Fenwick Hall's three stories contained luxurious rooms and 12-foot-wide corridors. The veranda was 400 feet long and 16 feet wide. The day after it opened, the first train arrived from Hartford with the president of the railroad, politicians, business executives, and directors of New Saybrook. Near the railroad and steamboats, it was a luxurious and popular hotel for wealthy patrons for many years.

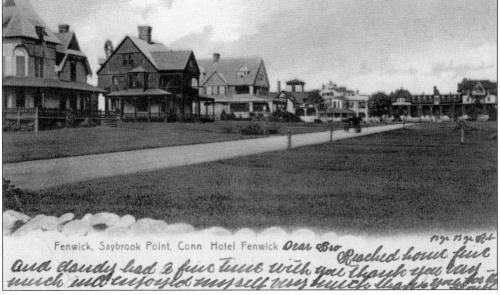

Among the notable Hartford celebrities to spend the summer at Fenwick Hall in 1872 was Mark Twain. Based on recollections by his longtime personal secretary, and more recent work by literary scholars, there is reasonable evidence that he began writing *The Adventures of Tom Sawyer* while summering there with his family. In addition to playing pool and telling stories to entertain the young ladies, he also perfected his only successful invention, a self-sticking scrapbook.

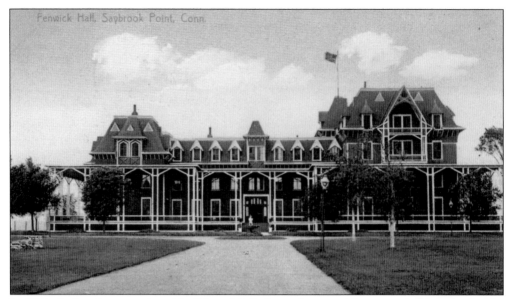

In 1889, the hotel was purchased by Edward S. Stokes, who served four years in Sing Sing for the murder of his partner "Jubilee Jim" Fisk in 1872. Stokes quarreled with the town over repairing the bridge to Fenwick and refused to pay his taxes. Fenwick Hall was placed at auction and purchased for $500 by Morgan G. Bulkeley, a prominent Fenwick resident and president of Aetna Life Insurance, who became mayor of Hartford, governor, U.S. senator, and first president of the National Baseball League.

The Hartford Yacht Club, built in 1900, held several well-attended regattas, although members often did more socializing than yachting. One member, a prominent insurance company president, frequently donned his bathing suit, long black stockings and sneakers, sun helmet, and light coat to protect his arms from sunburn, rowed against the wind to the breakwater, hoisted an umbrella and sailed toward home. In April 1917, Fenwick Hall suspiciously caught fire, and sparks flew across to the yacht club, and both buildings were completely destroyed.

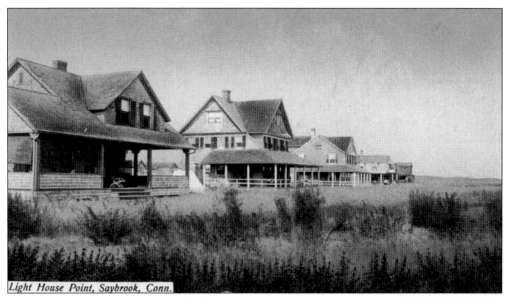

Light House Point, Saybrook, Conn.

These homes were built near the lighthouse and on the shore of Long Island Sound. They can be seen in the aerial view to the right of the Inner Light. Access was over a bridge and along the Connecticut River on a gravel road. Across the river in Old Lyme were protected areas, rich in birdlife, often illustrated by the ornithologist, artist, and educator Roger Tory Peterson.

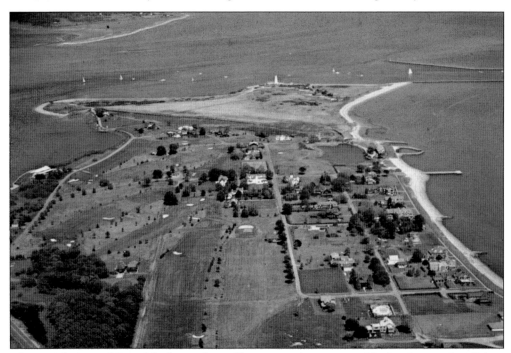

This aerial view of Fenwick shows the golf course and cottages with the Connecticut River and the lighthouses. Golf was first played at Fenwick in 1896, when a few residents laid out a course with circular greens about 10 feet in diameter, tomato-can holes, and homemade flags. Tees were approximately 200 yards apart. In 1929, a new borough office and barn were built. The improved course is now open to the public.

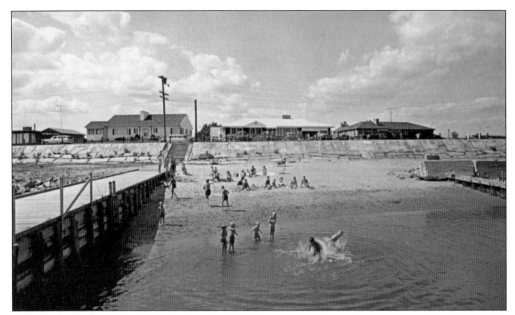

Fenwood was developed by retired Hartford physician Dr. A. W. Branon, just after World War II. Concerned with attractiveness and good taste, Dr. Branon reserved the right to approve all construction plans. A 12-foot-wide pier provides a protected beach and swimming area. A section of the rocky shore is covered with sand and held in place by a seawall to create a popular picnic and play area.

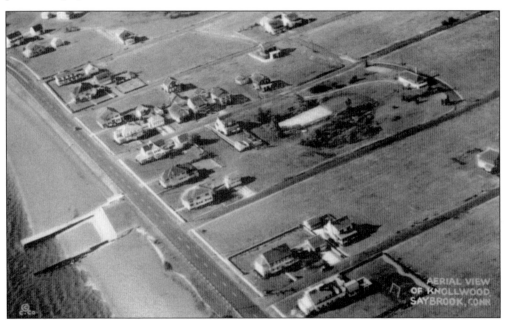

Established by a special act of legislature in 1929, the Knollwood Improvement Association encompassed a large tract of pasture bounded by South Cove and on its southern edge by a road that separated it from the stony beach and Long Island Sound below. Developed by Elva Simpson and Joseph Cosulich, a longtime former town clerk, they offered several hundred "restricted cottage sites," which they promoted as "a perfect setting for a high-class summer residential community."

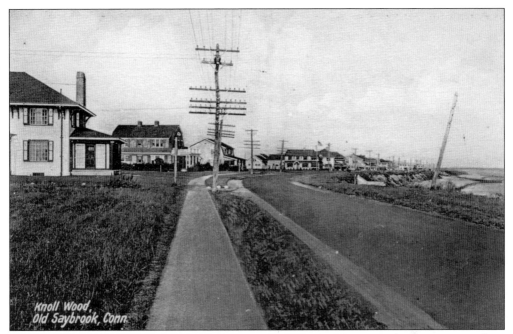

While much of the land was still home to grazing cattle, residents from Hartford began to purchase lots. Drawn by the promise of increasing value of shoreline property, the area developed slowly during the difficult Depression years of the 1930s. Many new houses filled the open lots after World War II, and today there are over 360 properties with little or no room for more.

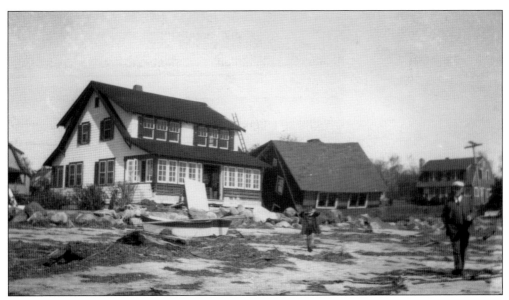

The hurricane of 1938 caused widespread devastation. Many substantial houses in Knollwood and elsewhere were destroyed, while many often flimsy and exposed summer cottages were blown apart and swept away.

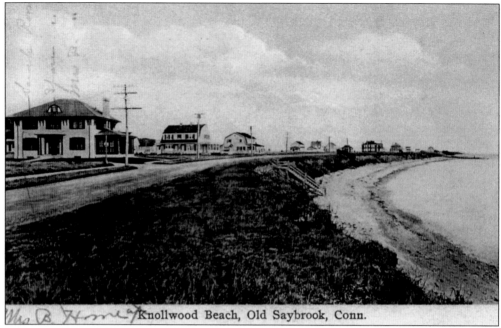

Knollwood Beach, Old Saybrook, Conn.

A clubhouse was constructed in 1929 and eventually the nearby marsh-like area was filled to make play areas. Influenced by the luxurious "cottages" at nearby Fenwick, early residents soon constructed stately homes overlooking Long Island Sound. Residences are separated from the sound by Maple Avenue (Route 154) and a wide walkway that runs the length of association area and serves as a promenade for walking and leisure activities. (Courtesy of Roy Lindgren.)

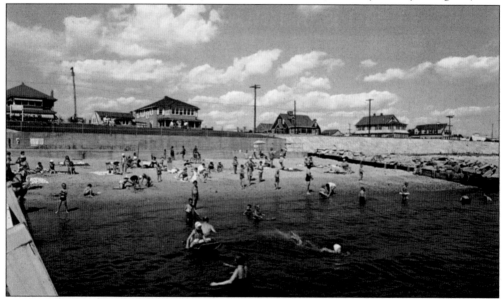

Until the early 1970s, the Knollwood Beach Association (KBA) owned the limited swimming area between the two piers. The remaining beach area was the property of the Trask family who sold it to a small group of KBA members for $30,000. The following year, the association purchased the land from the members for the same price. Today the association owns roughly 3,000 feet of beachfront, extending from Cornfield Point to Fenwood.

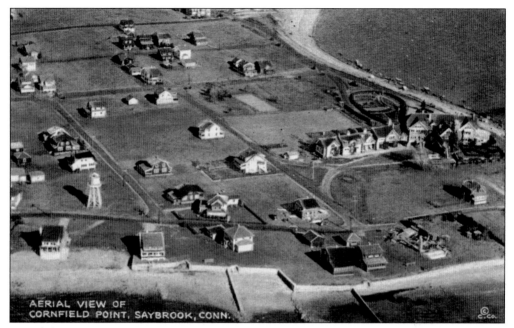

AERIAL VIEW OF
CORNFIELD POINT, SAYBROOK, CONN.

Cornfield Point was, indeed, the location for cornfields planted by the first colonists. Bounded by its rocky coast, the large size and prime location of the "Castle," built in 1906, is easily seen. The pile of rubble seen between the Castle and the shoreline was a dance hall destroyed by fire. Built in the 1920s, the water tower was fed by wells under the association clubhouse through a system of pipes that served all streets until abandoned in the 1950s.

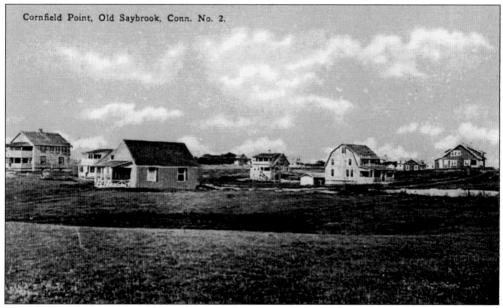

Cornfield Point, Old Saybrook, Conn. No. 2.

Scattered amidst the gently rolling hills are several cottages dating from the 1930s. The building in the left forefront was a Coast Guard radio station. Area residents called it the "Breakers," which came from common utterances of the messages, "Breaker! Breaker!" (Courtesy of Roy Lindgren.)

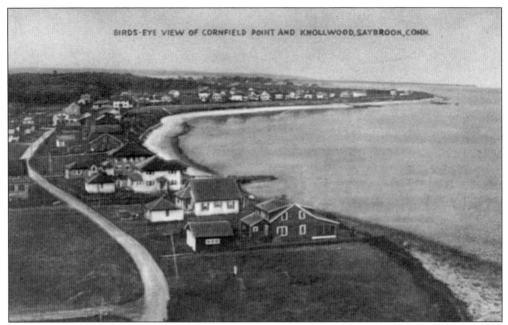

This aerial view shows Sea Lane in Cornfield Point as it winds along the shore toward Maple Avenue and Knollwood in the distance. The open lots have been filled with new cottages, and many older structures have been rebuilt or replaced. Long Island and smaller islands can be seen from this shoreline, and many residents also have views of the outer lighthouse.

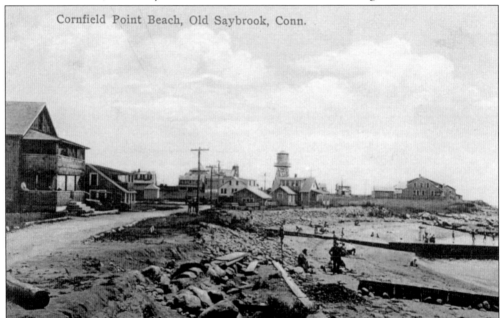

Cornfield Point Beach, Old Saybrook, Conn.

This early view of the beach shows the unpaved Town Beach Road along a very rocky and rugged beach with wooden jetties gallantly attempting to hold the sand in place. That portion of the road has been replaced with a paved walkway above a sandy beach, and a stone embankment prevents erosion. Two large stone groins have replaced the wooden barriers and keep most of the sand on the beach. (Courtesy of Roy Lindgren.)

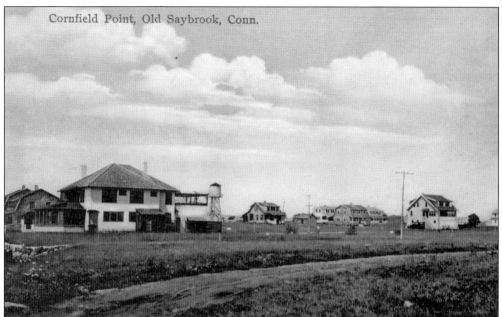

Cornfield Point, Old Saybrook, Conn.

Many of the summer cottages were constructed in the 1960s when most of the area was developed. The signature features were pine paneling and a living room fireplace of beach stone. Many cottages have been converted to year-round residences, and several maintain some of the earlier appearances. (Courtesy of Roy Lindgren.)

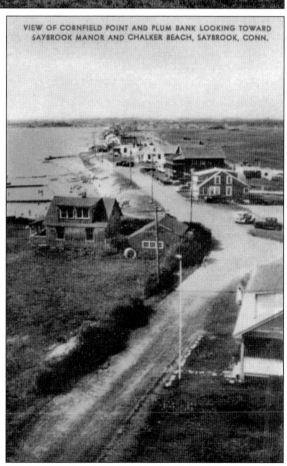

VIEW OF CORNFIELD POINT AND PLUM BANK LOOKING TOWARD SAYBROOK MANOR AND CHALKER BEACH, SAYBROOK, CONN.

From this point, one looks west to see several beach communities that line Saybrook's shore. Two early automobiles can be seen at the corner of the unpaved Town Beach Road and West Shore Drive. The larger cottage on the left was used by the Coast Guard during World War II, and much of the vacant land shown here has long since been occupied by cottages.

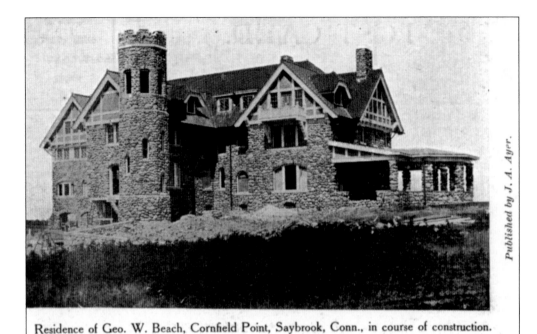

Published by J. A. Ayer.

Residence of Geo. W. Beach, Cornfield Point, Saybrook, Conn., in course of construction.

Beginning in 1906, George W. and Elizabeth Jarvis Beach spent $350,000 and two years constructing a "summer cottage" on a bluff known as Cornfield Point. George inherited a large Hartford insurance fortune. Elizabeth inherited a substantial sum from her aunt—the widow of Samuel Colt, the famed firearms manufacturer—Elizabeth Hart Jarvis Colt. Elizabeth named their cottage "Hartlands." Today the name Hartlands remains as the name of the road that leads to the castle.

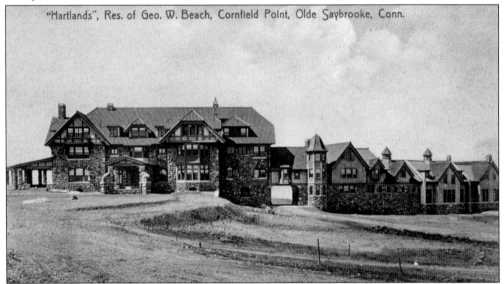

"Hartlands", Res. of Geo. W. Beach, Cornfield Point, Olde Saybrooke, Conn.

George Beach referred to Hartlands as the "Castle," as it reminded him of those found in Europe. Constructed of beach stones and topped with a distinctive red tile roof, dozens of workers labored two years to complete the landmark. Each May and August, amidst the formal gardens, stables, and servants' quarters, George would host extravagant parties and invite the entire town. In 1918, the Beaches leased the building for $1 a year to the U.S. Army. The building housed 40 officers and a stockpile of ammunition.

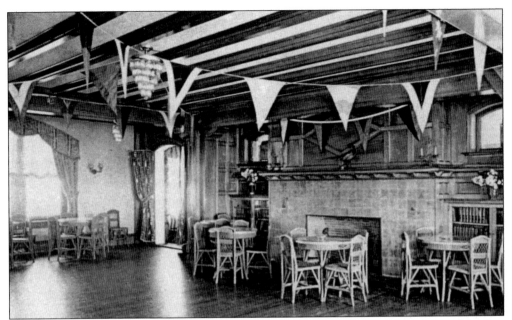

Its rustic, but warm, interior became a favorite gathering spot for socialites and celebrities, including stars of the stage, like Ethel Barrymore, who appeared in a performance at the town hall, and Helen Hayes, Charlie Chaplin, and others who performed at the Ivoryton Playhouse. With its incomparable view of the sound, lively dance bands, fine food, and cocktails, it is easy to understand its popularity. Each spring, a staff of 25 or more readied the hotel and prepared the gardens for the upcoming season. (Courtesy of Roy Lindgren.)

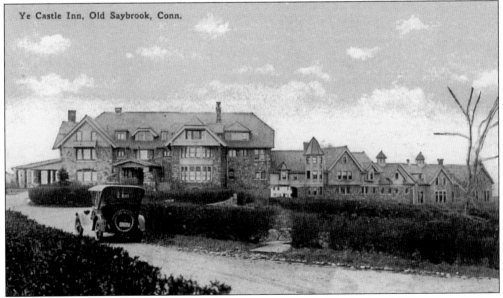

George Beach died in 1921, and to pay a $35,000 mortgage, Elizabeth sold 25 acres to Gilbert Pratt of New York, who then sold it to summer housing developer James Jay Smith. In 1923, the mansion with 3.5 acres was sold to Otto and Margaret Lindbergh for $75,000. A relative of the famed aviator Charles Lindbergh, Otto and wife, "Maggie May," converted the residence into an elegant hotel and restaurant and named it "Ye Castle Inn." (Courtesy of Roy Lindgren.)

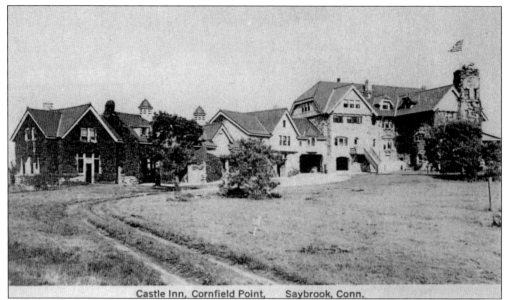

Castle Inn, Cornfield Point, Saybrook, Conn.

During Prohibition, Otto and Margaret prospered by running Ye Castle Inn and a rum-running operation that supplied many shoreline establishments. Their supplier was son-in-law Augie Campbell Strusholm, a World War I veteran and owner of several high-powered cruisers that were faster than government boats. The contraband liquor would be picked up by local fishermen off Montauk Point, known as "Rum Row," and then transported to Ferry Point, Cornfield Point, Indian Town, and other locations along the shoreline. (Courtesy of Roy Lindgren.)

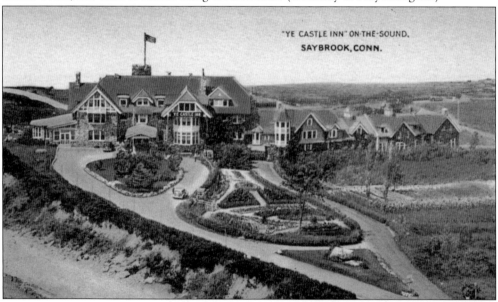

"YE CASTLE INN" ON-THE-SOUND, SAYBROOK, CONN.

Once inside the Castle, the liquor would be hidden behind false walls and in large closets in "guest" rooms. A radio alerted owners and patrons to government raids, a tip often provided by friendly state and local police. A 1931 newspaper article reports that, "a large quantity of alleged intoxicating liquor was seized . . . [and] Mrs. Margaret Lindbergh, who claimed to be the proprietor of the place, was arrested on charges of sale and possession of liquor and maintenance of a nuisance."

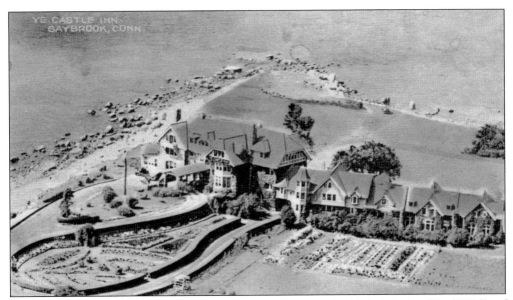

Margaret Lindbergh kept the Castle through World War II and sold it in 1950 to "Red" Kelly of Wethersfield. In 1955, it was sold at auction for $65,000 to the Tagliatela family, current owners of Saybrook Point Inn, and reopened in 1957 as an inn. The Castle slowly faded and changed hands several times. In the late 1990s, a portion of the original building, fondly known by locals as "Divorce Row," was removed and adjacent land was sold.

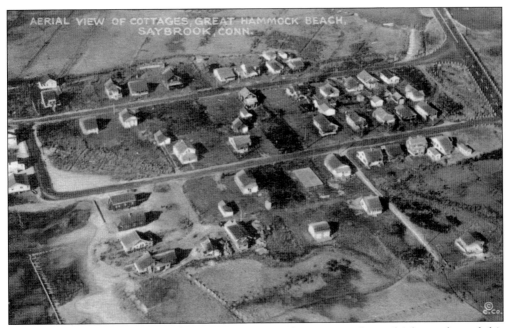

Since 1693 to 1694, when Nathaniel Lynde allowed the town to place a highway through his land to the Plumbanks, residents and visitors have been attracted here for its high bank of sand. Early settlers used it in making mortar for building purposes. Even before the highway, settlers were drawn to the clam flats on one side and the salt meadow in back of the sandbanks.

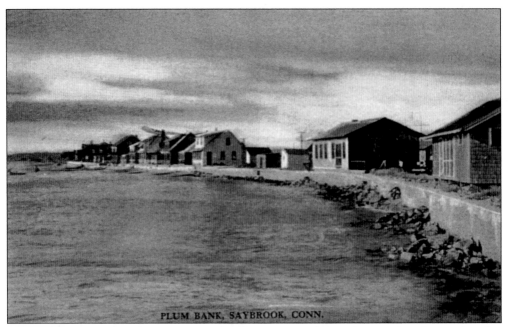

For $200 one could buy a lot on which to build a cottage and view the sound or the marsh. After a long, hot drive from upstate, summer residents would arrive at their hammock-shaped barrier island paradise. Once here, children would play on the beach, learn to swim, run on the flats at low tide, dig for clams, go to the creek for crabs, and listen to the crashing waves and watch the passing clouds. (Courtesy of Roy Lindgren.)

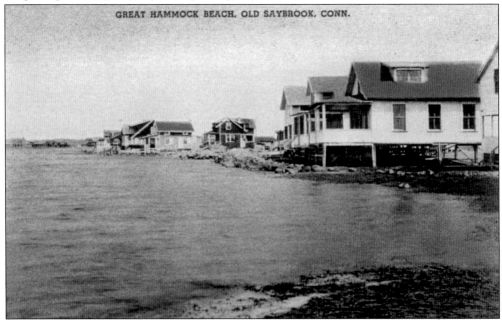

From Monday through Friday, father would be back at work and mother would be preparing food and handling cottage chores. Water came from a rain barrel or community well. Everyone used an outhouse or, in the evening, had a pot under the bed. Lifetime friends were made, and by Labor Day, life once again returned to more serious pursuits. (Courtesy of Roy Lindgren.)

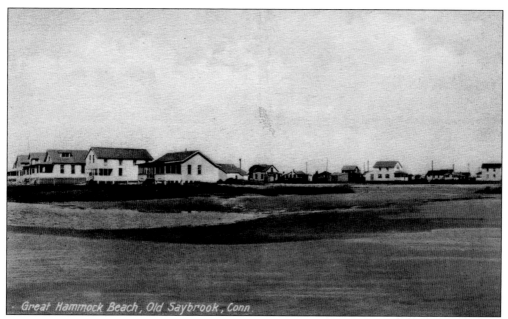

Great Hammock Beach, Old Saybrook, Conn.

On hot summer days at low tide, it has become popular for beachgoers to stroll in the shallow, cool water for quite some distance, parallel to the shore. In addition to its large expanse of low water and flat land, there are days when a seasonally strong wind draws wind surfers with brightly colored chutes to skim at great speeds along the water's surface.

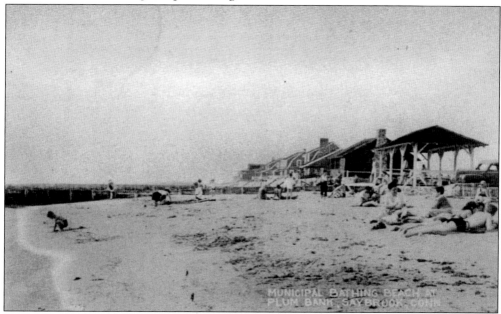

MUNICIPAL BATHING BEACH AT
PLUM BANK, SAYBROOK, CONN.

Although Saybrook fronts Long Island Sound, it was not until 1935 when residents appropriated $3,500 to purchase land for a municipal beach. A pavilion was added in 1955. But, four years later at a well-attended town meeting, residents refused to spend $73,500 to enlarge the beach. When another beach was offered to the town, with the stipulation that it retains its name of "Harvey's Beach," residents engaged in a heated discussion before finally approving its purchase. (Courtesy of Roy Lindgren.)

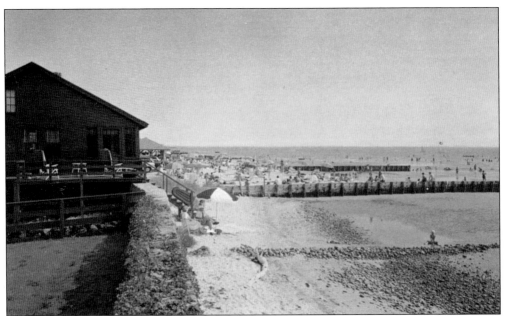

To ease overcrowding on the Town Beach, in 1983, residents purchased, for $240,000, a nearby 6-acre private beach, run by Francis and Violet Harvey, which had been in the Harvey family for 200 years. Francis Harvey's great-grandfather grew meadow grass that was harvested and taken to New York to be sold as horse feed. Early members of the family also deeded land to the state, on which today's Great Hammock Road was built.

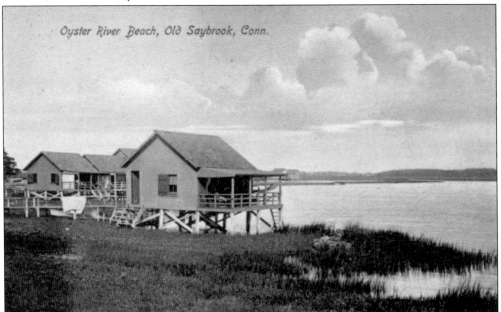

This beach area was located along the west side of the Oyster River, about halfway between the Boston Post Road and the mouth of Oyster River. These summer cottages on stilts washed away in the 1938 hurricane. With debris widely scattered, people returned to gather up remaining belongings. None of the cottages were rebuilt or replaced, and the area became a wide strip of marshland along the river.

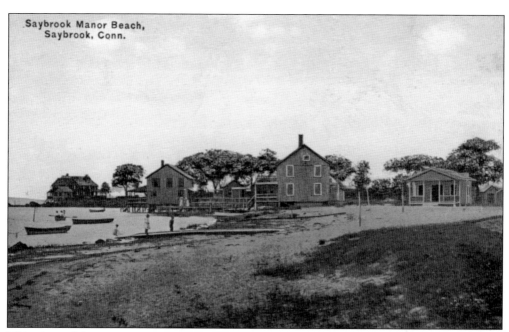

This view of the Oyster River Beach is toward Saybrook Manor Beach. The distant cottage at the point of land (on the left) was known as the Wise Smith cottage. Owned by Isadore Wise, a prominent Hartford businessman, the first floor was totally washed out in the 1938 hurricane.

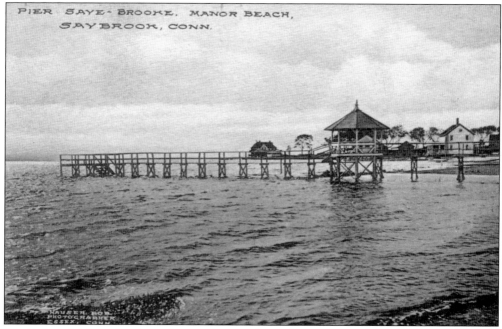

The Saybrook Manor beach area has two long roads, Middletown and Hartford Avenues. Cottages lined each side of the road. Residents volunteered to build long piers at the end of each road. Each had a summerhouse about halfway out, with steps into the water. The 1938 hurricane made kindling wood out of the piers. They were rebuilt at half their length, but another storm left them in tatters.

Residents named the streets for the cities from which they came: Hartford, Middletown, Waterbury, and New Britain. The very earliest electric poles can be seen here. Prior to these, there was no electricity or refrigeration. Fitzhugh ("Fitz") Dibble cut ice from Crystal Lake in the winter and stored it in great blocks in the icehouse on Schoolhouse Road. In the summer, he delivered it door-to-door from his horse-drawn wagon and later from the back of a truck. Ice chips for kids, free!

Saybrook Manor was developed by James J. Smith Company in the 1920s from farmland formerly owned by George W. Denison. Tents and outhouses were the first structures, closely followed by summer cottages lined along narrow streets. Families would drive down from points north, stock up on groceries at Stokes Store on Main Street, and move to the beach for the weekend or for the summer. (Courtesy of Roy Lindgren.)

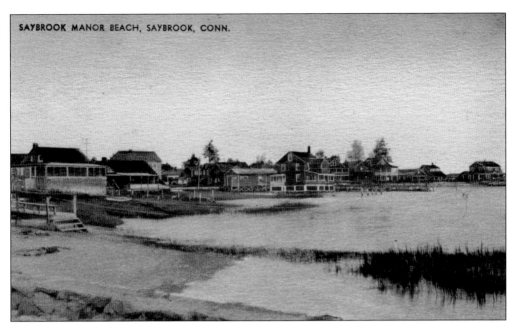

SAYBROOK MANOR BEACH, SAYBROOK, CONN.

An early resident recalls: "Life at the beach meant long sunny days living in a bathing suit, lying on the warm sand, and learning to dive and swim under water longer than the 'new' kids. The most fun was catching crabs, which we sold for bait at two crabs for a penny. We'd save every cent and then buy fireworks at Parker's Store for the Fourth of July."

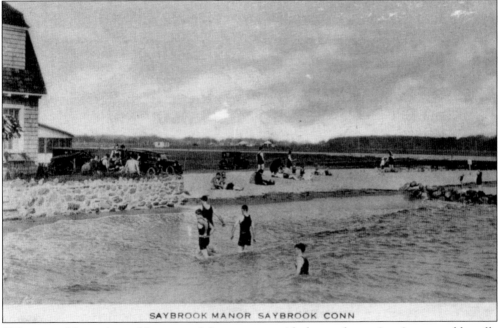

SAYBROOK MANOR SAYBROOK CONN

"The vegetable truck would go up and down streets with the vendor crying, 'veg-a-ta-bles, all-a-fresh veg-a-ta-bles.' Fitz Dibble would deliver a large block of dripping ice into the kitchen and place it in the wooden ice box. Twenty-five pounds would last for two or three hot July days. We lived on seafood and took many clams from the sand flats and many oysters from Oyster River to eat raw or make casseroles."

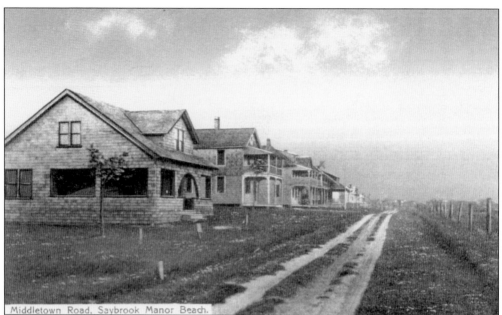

Middletown Road, Saybrook Manor Beach.

In *Faces and Places of Old Saybrook: A Historical Album*, "Summertime at My Grandparents' Cottage," Barbara J. Maynard writes, "Summer friendships were made, some lasting seasons. Others a lifetime. Every summer we'd watch for the neighbors' cars to arrive from the city hopefully loaded down with enough kids for hide and seek every night all over Saybrook Manor. There were very few homes then, so there were many open lots with berry bushes and trees, which made great hiding places."

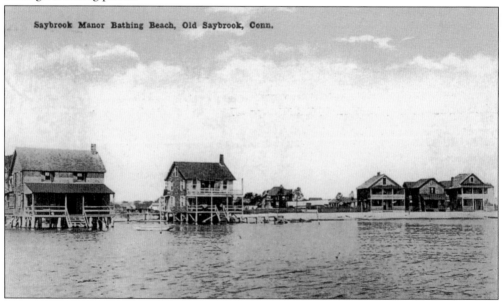

Saybrook Manor Bathing Beach, Old Saybrook, Conn.

In the 1920s and 1930s, cottages were built on piers over the water. The tide came right up the front stairs and made swimming very convenient. These water cottages were always rented. The sound of waves under the house was much better than loud city noises, if only for a two-week rental period. These cottages were completely destroyed by the 1938 hurricane, and debris was found hundreds of feet inland. (Courtesy of Roy Lindgren.)

114

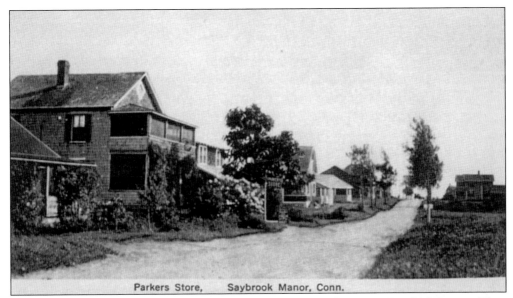

Parker's Store was first located in Mr. and Mrs. Frank Parker's home on Hartford Avenue. They sold groceries, Cliquot soda, Tootsie Rolls, ice cream cones, sand pails and shovels, even water wings. Mrs. Parker received the mail and passed it out when a resident came to the store. The first pay telephone was on the front porch and used by most cottage owners. Mrs. Parker also made soap and shaped it in an old candy box. It looked like fudge, and more than one youngster learned the hard way that it was not. (Courtesy of Roy Lindgren.)

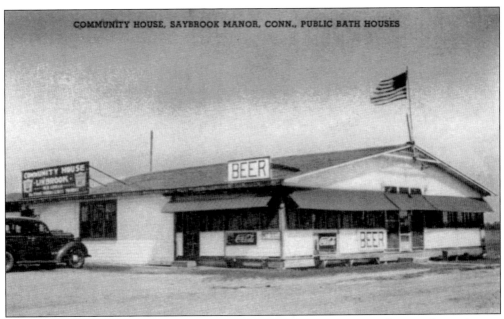

The Community House offered beer and soda for hot and thirsty residents and vacationers. Children enjoyed delicious 5¢ ice cream cones. It was located near Shenker's pier. And, like many other beach buildings in the 1938 hurricane, it was washed away, ending up on Great Hammock Road, where it was found resting on its roof. It was skidded across the meadows for its return. (Courtesy of Roy Lindgren.)

Sea Lane served as the dividing line between the Denison farm that became Saybrook Manor and the Chapman farm that became Indian Town. This early automobile marks a transportation and social turning point. A growing number of summer residents arrived in the family automobile, and far fewer needed the railroad, trolley, or the horse. It also allowed the breadwinner in the family, almost always the father, to work during the week and rejoin the family for weekends. (Courtesy of Roy Lindgren.)

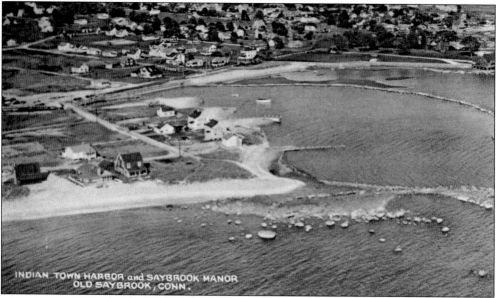

This aerial view shows Saybrook Manor, which was developed by James H. Smith from the Denison farm. It also shows Indian Town, which was developed from land owned by the Chapman family, since Robert arrived in the 1630s with Lion Gardiner to establish the town. In 1666, Robert Chapman bought the land from Uncas, the Mohegan sachem. Some 250 years later, his ancestors H. T. and F. S. Chapman began developing it as Indian Town.

ENTRANCE TO INDIAN TOWN, FROM BOSTON POST ROAD, SAYBROOK, CONN.

Stone pillars topped with arrowheads marked the entrance to Indian Town, across from today's high school, which was also part of the Chapman farm. This mid-1920s view shows the area still being farmed. The Chapmans grew corn and raised sheep, which can be seen here to the left. Arrowheads and other objects were commonly found in newly turned soil.

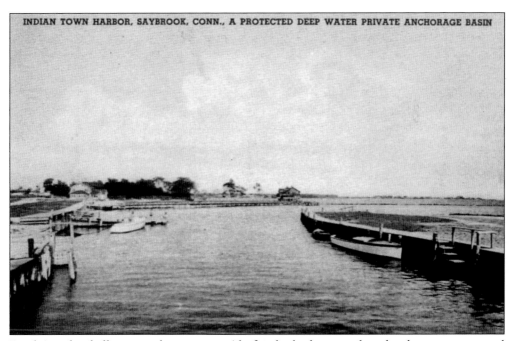

INDIAN TOWN HARBOR, SAYBROOK, CONN., A PROTECTED DEEP WATER PRIVATE ANCHORAGE BASIN

Dredging the shallow area that was set aside for the harbor was done by the steam-operated Potomac, one of 30 dredgers owned by the Arundell Corporation of Baltimore. Sand dredged from by hydraulic pump was sent through a pipeline to reclaim 20 acres of marsh. All went well until the Potomac sunk some 500 feet from the beach. (Courtesy of Roy Lindgren.)

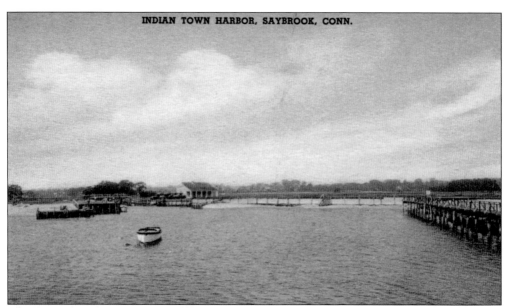

INDIAN TOWN HARBOR, SAYBROOK, CONN.

Eventually a breakwater was constructed, and the harbor was completed. It was 10 feet deep and measured 300 feet wide by 500 feet long. Over the years, the harbor has required occasional dredging to maintain its depth. Separated from the swimming areas by man-made jetties, the boat basin remains a popular attraction for residents and visitors.

INDIAN TOWN OFFICE, SAYBROOK, CONN.

The Chapmans established an office on Obed Trail and advertised that the property rose gently from the water, and every lot caught the sea breezes. The trails, they said, were "hard packed and dustless." Lots were high and dry and had rich loam and trees. Most lots were 50 by 100 feet, and they advertised that there would be a modern water system and electric lights with telephone service available.

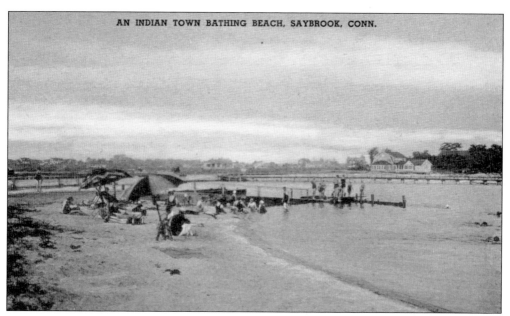

AN INDIAN TOWN BATHING BEACH, SAYBROOK, CONN.

Large flat areas of shallow water made the beach popular with families having small children. Under canvas beach umbrellas, children played in the sand or water with a popular toy that was set on the ground or in the water and used as a pump. Today the shallow "baby beach" is next to the gazebo.

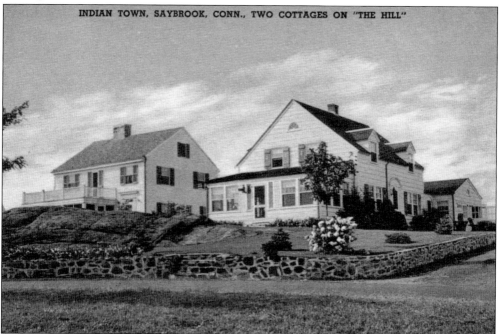

INDIAN TOWN, SAYBROOK, CONN., TWO COTTAGES ON "THE HILL"

By the mid-1930s, when these two cottages were built on Jackson Hill, some farmland and pasture remained. The Chapmans were hit hard by the Depression and sold their remaining interest to the Aquaterra Company. They built their first houses in 1935, and then they sold to James Jay Smith's son. He took the remaining lots between the Boston Post Road and the old Post Road and developed year-round houses on larger lots. He also set aside 12 acres of wetlands.

LAZARRE LODGE INDIAN TOWN, OLD SAYBROOK, CONN.

Bob and Hetty (Henrietta) Lazarre were energetic, creative, and outgoing residents with a background in show business. They attracted intellectual, artistic, and fun-loving friends and guests from Hartford to their summer cottage in Indian Town. Bob was an early advocate of physical fitness and conducted calisthenic sessions early each morning on the beach. What started as a cottage with friends expanded to a lodge with boarders. Finally a two-story building and patio was added to face Long Island Sound. (Courtesy of Roy Lindgren.)

LA ZARRE LODGE, INDIANTOWN (ON THE SOUND)
OLD SAYBROOK, CONN.
PHONE 313.

During the 1930s and 1940s, weekend guests often had to rent rooms from nearby cottages to be able to have their meals and enjoy the activities with the 50 or 60 guests at what the area children called the "Lizard Lodge." Eventually the Lazarres sold the lodge and other small buildings. The Indian Town Association had a chance to buy the place for $140,000 in early 1970s, but turned it down. Today the lodge and the outbuildings are condominiums. (Courtesy of Roy Lindgren.)

120

Crystal Beach Camp was a popular summer camp for young people. It was run by Charles McTernan, a Waterbury school principal, and organized around a large building shown here and several small cabins for the campers. The area was later purchased and divided into about 20 residential lots that became known as Bel-Air Manor. (Courtesy of Roy Lindgren.)

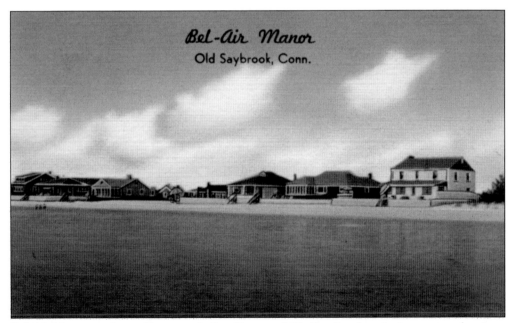

Bel-Air Manor was located between Indian Town and Chalker Beach, enjoying spectacular views of the water and marsh. Although it is close to the early Lazarre Lodge area in Indian Town, it is accessible only from Chalker Beach and was originally part of the Crystal Beach Camp.

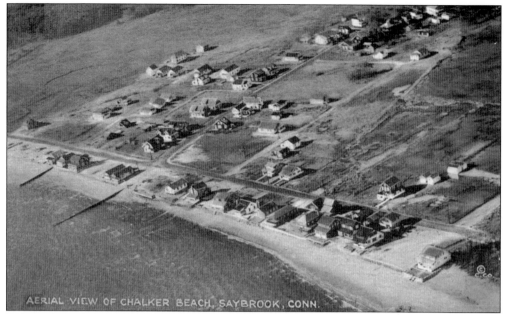

In 1927, Harry Barnes and C. H. Chalker formed the Chalker Shore Properties and the following year contracted with the Holbrook Company to fill the marsh north of the shoreline. Using material dredged from Long Island Sound, more than 150 building lots were created and streets planned. The area shown in the middle of this image remains today as wetlands without development.

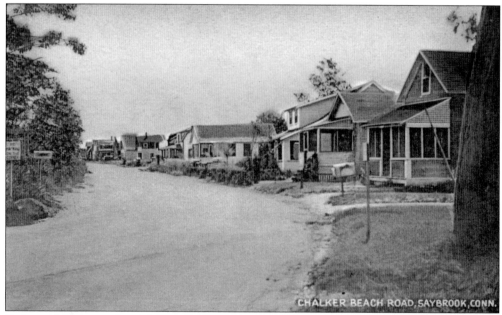

Early roads were made of dirt, and the story is told of residents placing railroad ties over the dirt road, oiling the ties, and then adding more soil until they were accepted and maintained as town roads. Chalker Beach Road became a town road in 1939. Several streets were named after early residents—Burgey, Tucker, DeRenne, Elinot, Kenn, and Pelser. There is also a Saye Street and a Brooke Street.

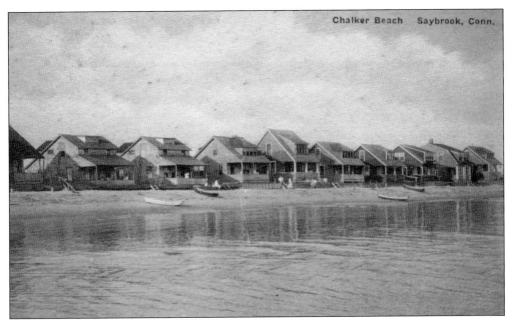

Early cottages were on 40-foot-by-100-foot lots. The developers stated that it was "a rare opportunity for a man of moderate means to own an inexpensive home on the Sound." Boats were launched from backyards. Boaters who did not live directly on the water used a flatbed, mounted on large, old carriage wheels, and pulled their boats to the beach.

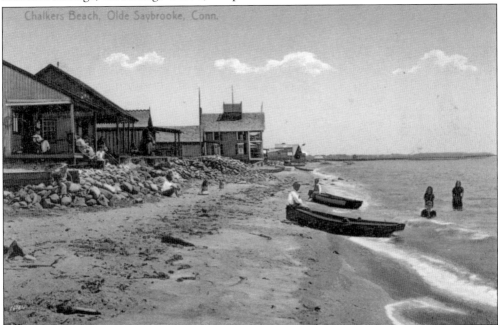

The association often employed a constable to check cars and maintain "law and order." Frederick Burgey had this position for many years and easily handled his tasks with support from his German shepherd. When he encountered rowdy youngsters, he would snap his fingers, and the dog would sit up, which was enough to convince any offender to change his behavior or leave the scene.

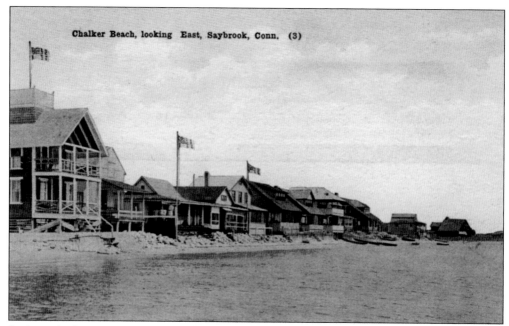

Chalker Beach, looking East, Saybrook, Conn. (3)

In the early days, most cottages used coal stoves for cooking and heating. There was no running water and residents filled 5-gallon jugs of water on their way to the cottage. Outhouses, of course, were in common use. Some residents named their cottages. Some were converted to year-round residences, and their owners eventually moved to Old Saybrook. Mail was picked up at the Chalker Beach store, where Olin Oldershaw usually had a treat waiting for young mailmen.

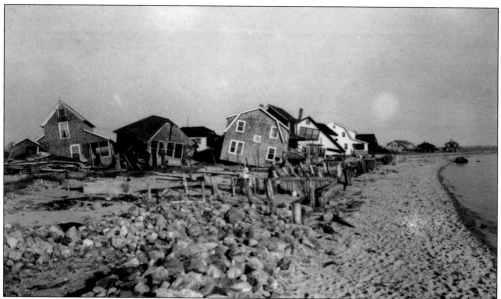

The hurricane of 1938 inflicted great damage along the shoreline. Entire houses were washed away and later found a mile or more from their original location. Two people were swept away at Chalker Beach. After the storm passed, some enterprising residents took the remains from cottages that washed away and made them into new houses.

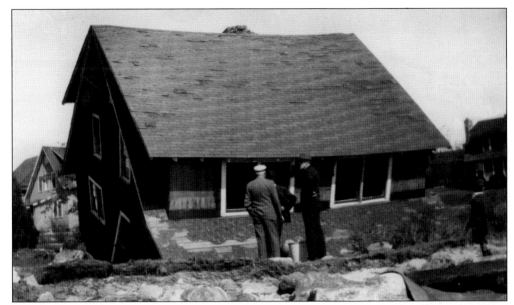

In December 1938, after the devastating hurricane moved the clubhouse, the association voted to return it to the land where it originally stood on Tucker Road. The facilities are used for association meetings and beach-related activities. A second clubhouse exists on Beach Road West, directly across from the beach. It provides accommodations for beachgoers and security personnel to check on parking. Shown here is John Burdick, Westbrook town assessor, helping local officials tallying the damage.

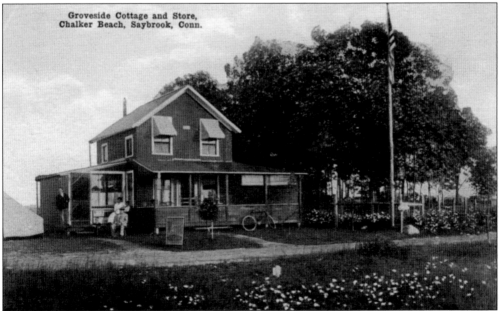

In the days when the man of the house was the sole support for the family, husbands would go off to work, and wives would take care of the house and shopping. They often walked to the Groveside Store, built in 1917, to buy groceries from the proprietor, Olin Oldershaw, who also owned the house next door. For a special treat, they would buy a case of Merrill Star Beverages, a local soda bottler.

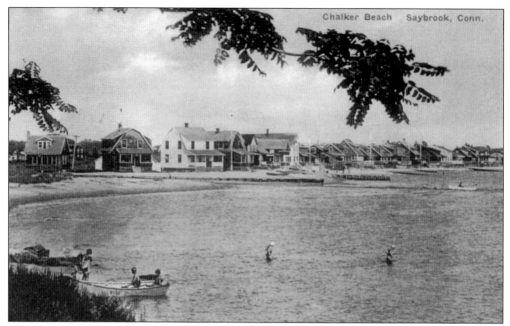

Over the years, some vacationers converted their structures to year-round residences. Children who grew up on the beach and learned to swim, row a boat, fish, or romp in the water, often carried on the traditions of their parents and spent summers here or became year-round residents of the community. (Courtesy of Roy Lindgren.)

Pictured above is a special message for the friends of Old Saybrook.

OLD SAYBROOK

CONNECTICUT

The seal of Old Saybrook was adopted from the college arms of Saybrook College of Yale University. The upper left and lower right sections are for Fiennes, the family of Lord Saye and Sele; the upper right and lower left sections are for Greville, the family of Lord Brooke, two of the 17th century English proprietors of land at the mouth of the Connecticut River. Their names were combined in the name of Saybrook Colony, which was the site of Yale University, before its removal to New Haven in 1716.

www.arcadiapublishing.com

Discover books about the town where you grew up, the cities where your friends and families live, the town where your parents met, or even that retirement spot you've been dreaming about. Our Web site provides history lovers with exclusive deals, advanced notification about new titles, e-mail alerts of author events, and much more.

MADE IN THE
USA

Arcadia Publishing, the leading local history publisher in the United States, is committed to making history accessible and meaningful through publishing books that celebrate and preserve the heritage of America's people and places. Consistent with our mission to preserve history on a local level, this book was printed in South Carolina on American-made paper and manufactured entirely in the United States.

Find Your Place in History.